IMAGES
of America

THURBER

ON THE COVER: Mine No. 9 opened in 1899 and closed in 1911 after miners had extracted 950,000 tons of coal. At a depth of 190 feet, the coal varied in thickness from 24 to 28 inches. (Courtesy of the Lorenz Collection, W.K. Gordon Center.)

IMAGES
of America

THURBER

Deborah M. Liles

ARCADIA
PUBLISHING

Copyright © 2021 by Deborah M. Liles
ISBN 978-1-4671-0556-9

Published by Arcadia Publishing
Charleston, South Carolina

Printed in the United States of America

Library of Congress Control Number: 2020951073

For all general information, please contact Arcadia Publishing:
Telephone 843-853-2070
Fax 843-853-0044
E-mail sales@arcadiapublishing.com
For customer service and orders:
Toll-Free 1-888-313-2665

Visit us on the Internet at www.arcadiapublishing.com

This book is dedicated to all of the men, women, and children who called Thurber home, and to Noah and Madden, whose ancestors came from the coal-mining pits of England and Wales.

CONTENTS

ACKNOWLEDGMENTS

This book began as a combined undergraduate and graduate research class. Credit for my students as researchers and contributing authors needs to be given to Mitchell Bernard, Cord T. Flory, Juan L. Garcia, Lindsay J. Hatfield, Cristobal Lopez, John M. McKinney, Jordan Moore, Nadeya J. Patel, and Lorien Winton. Thank you to Mary Adams, Shae Adams, Lea Hart, and Kyndall Howard at the W.K. Gordon Center (WKGC) for assistance with research. Special thanks to T. Lindsay Baker for his work as my predecessor and to Rebecca Sharpless and Jensen Branscombe for their support. Facebook friends deserve a special shout-out for helping identify machinery, cars, tractors, and other items. Archivists Phyllis Kinnison and Tracy Holtman at the Dick Smith Library, Tarleton State University; Brenda McClurkin, Michael Barerra, and Sara Pezzoni in Special Collections at the University of Texas at Arlington; Monte Monroe and James Marshall at the Southwest Collection at Texas Tech University; the Haley Library; and Mary Burk at Hardin-Simmons University all made this book possible. Leo Bielinski of the Thurber Historical Association and the Bennett family in Thurber deserve special recognition for their efforts to preserve Thurber's rich history. As always, many thanks and much love to Mike, Kelly, Chase, and Rosemarie. This book is a small sample of Thurber's past. We invite you to the W.K. Gordon Center in Thurber to discover more.

INTRODUCTION

In 1886, William and Harvey Johnson opened the coal mines that became the basis of Thurber, Texas. Created to capture business from the fast-approaching Texas & Pacific Railroad Company, the Johnsons' mines were one of several small operations in the region. The Johnson Coal Mine Company only lasted two years before William Johnson sold it to a group of investors based in New York City. One of these men, Robert Dickie Hunter, had been told about the mines by Jay Gould, owner of the Texas & Pacific. Another, Horace Kingsley Thurber, a successful grocery store magnate, loaned his name to the town. With Edgar Lewis Marston, Hunter's son-in-law, the men called their new business the Texas & Pacific Coal Company after their primary customer. With Hunter serving as the company's first president, mining began with a fervor in the company's new town.

Nestled in the hills of the Palo Pinto Mountain Range, Thurber's location at the far northern edge of Erath County was on a vein of rich bituminous coal that ran approximately 75 feet deep and up to 34 inches thick. Prospecting holes dug by a diamond-bit drill revealed that a large portion of the land contained coal that would generate large profits. Throughout the years, the Texas & Pacific Coal Company expanded the initial 22,000 acres purchased from the Johnson brothers to approximately 70,000 acres. With an estimated yield of 3,500 tons per acre, the company became one of the largest producers of coal in the Southwestern United States.

Hunter retired as general manager in July 1890 after a stroke and a disagreement with the company. William Knox Gordon, whom Hunter had hired the year before, replaced him as general manager and superintendent. Under Gordon's watch, which was seen as much different and more benevolent than his predecessor's, the company expanded, and Thurber's population grew to nearly 10,000 residents. Immigrants from 18 countries migrated into Thurber to engage in the coal or brick industries or the residual businesses in town. As they moved in, the company built them houses and provided company stores to sell them food, clothing, household necessities, and anything else they desired. They then added entertainment venues and provided modern amenities that were unavailable elsewhere. An electric plant, icehouse, farm, opera house, dry goods store, and other businesses created a community for multiple generations.

Thurber operated for 15 years without a union, but this changed in 1903. The United Mine Workers finally established the first local union after many years of trying, and others quickly followed. By 1907, Thurber was said to be the only fully unionized town in America. There were separate unions for the carpenters, the bartenders, the office workers, and everyone else with a trade. Dues, along with other monthly expenses, were deducted from employee's paychecks and union representatives continually fought for the rights of members and for better pay and shorter working hours. As was typical in extractive industries, there were several clashes between the company and the union over the years. The final incident in 1921 led to most of the coal mines closing and the company telling the miners to move out of its town.

Gordon began looking for sites to drill for oil in 1912, as he recognized that the transition from coal to oil was the future. Prospecting an area due east of Thurber against the recommendations of geologists proved to be another of his excellent business decisions. After a few failures, McCluskey No. 1 blew in on October 17, 1917. This gusher was the beginning of the Ranger oil boom that produced more than 20 million barrels of oil, but it also marked the end of the demand for Thurber's coal. As the railroad industry, the company's largest customer, switched from coal to oil, the Texas & Pacific Coal Company did the same, eventually changing its name to the Texas & Pacific Oil Company.

With the focus shifted to extracting high-profit oil in Ranger, not low-profit coal from Thurber, company employees relocated, and the need to maintain Thurber waned. Miners relocated to other mines in different states, returned to their countries of origin, or moved into local communities as the company decreased their wages. Brick plant employees remained in town, but that demand also decreased with the rising use of asphalt on roads. In 1933, the company moved its offices to Fort Worth to continue managing the profits generated by the Ranger oil fields. A fire gutted the downtown square in 1930, and the company demolished what was left of Thurber's structures in 1936, including the brick plant. Many of the houses were sold and moved out of town. By the end of the decade, there was little left of what had once been the largest town between Fort Worth and El Paso.

In the 50 years that Thurber existed, the United States went through the post-Reconstruction era, the turn of a new century, the Progressive Era, World War I, the Roaring Twenties, the stock market crash, and the beginning of the Great Depression. Throughout those years, enveloped in a company town in the Palo Pinto Mountains, Thurberites worked for the company extracting, manufacturing, and living their daily lives. This is their story.

One

THE COAL MINES

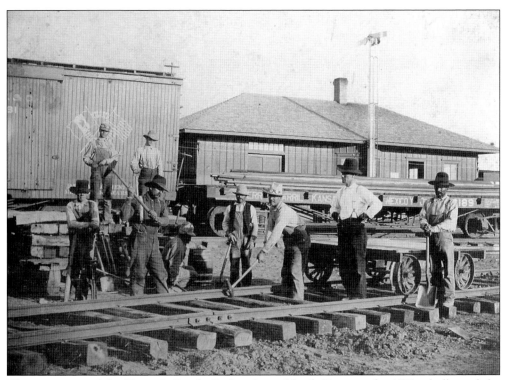

The expansion of the Texas & Pacific Railroad into North Texas in the 1870s challenged the company to find a new source for locomotive fuel. Before the rail lines expanded from East Texas, wood chopped by convicts and coal from mines in Indian Territory, Arkansas, and Alabama supplied the needed fuel. As the lines extended farther west, new and closer fuel providers meant higher profits. Thurber answered that call. This image is from several years later. (Courtesy of the Jordan Collection, WKGC.)

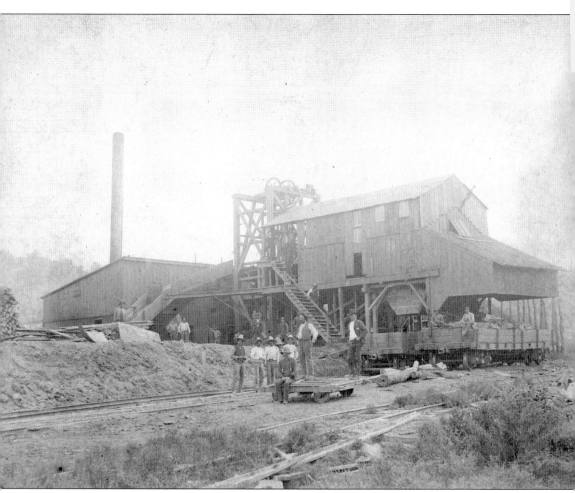

William Whipple Johnson sank the shaft for Mine No. 1 to a depth of 65 feet in October 1886 and discovered a vein of coal 26 inches thick. By August 1887, he had a contract with the Texas & Pacific Railroad to supply 200 tons of coal per day. Located just under the western perimeter of the future town of Thurber, Mine No. 1 operated until 1892 and produced approximately 130,000 tons of coal. (Courtesy of the Miles Hart Collection, Haley Library.)

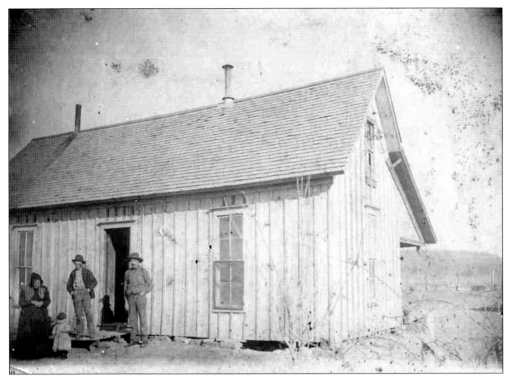

Many of the 450 miners who worked at the Coalville mines nearby moved to the Johnson Mines when they opened. Some, such as these settlers in 1886, had homes that were similar to the ones that would soon be built in Thurber. This pier-and-beam home has wood siding, windows, heat, a front porch, and an upstairs sleeping space. Water, which was scarce, would have been hauled in and stored in a barrel. (Courtesy of the Jordan Collection, WKGC.)

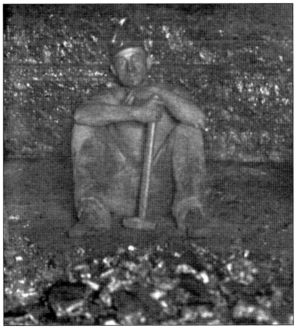

Black, shiny, and layered, bituminous coal is what was mined at Thurber. Of the four types of coal, it is second only to anthracite in carbon content. A sample from six Texas coal mines showed that Thurber's coal had the lowest moisture content, which meant it was light and required more to make a ton, but burned hotter and generated more power. Unfortunately for the miners, it also meant they had to work harder to earn their money. (Courtesy of the Thomas Collection, WKGC.)

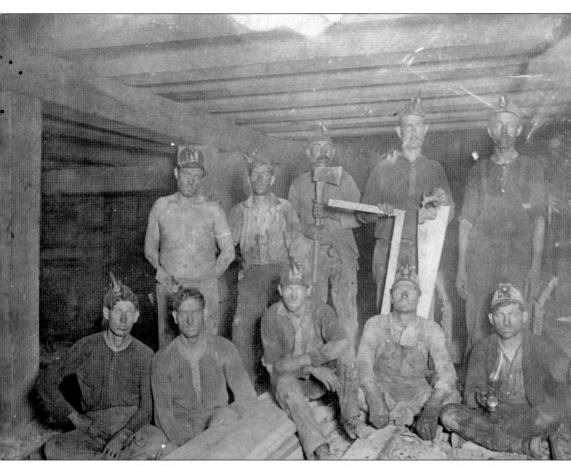

Mining records for 1889 chart the progressive rise of coal production at Mine No. 1. In January, 177 tons were brought to the surface; by October, the best month, 9,734 tons were surfaced. That year's total was 74,816 tons, and that was without the optimal amount of mining machinery for these miners, as it could not fit under the low ceilings in the tunnels. Coal from the No. 1 shaft had a fixed carbon rating of 56.98, No. 2 was 60.01, and No. 3 was 53.46, well within the bituminous range of 45 to 86 percent carbon. By December 31, 1889, T&P Coal Company had coal sales of $202,230, with a net profit of $22,003. (Courtesy of the Thomas Collection, WKGC.)

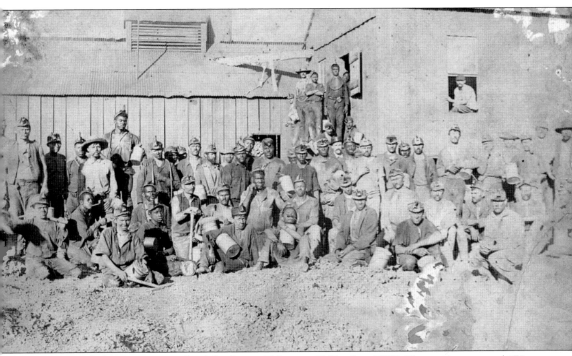

The first Black miners arrived in Thurber in February 1889, when W.D. Hunter transported 172 Black and White strike-breakers by train from Brazil, Indiana. Before they were used in Thurber, the Black miners had also been taken to Iowa and Colorado. Anticipating animosity and trouble from Union organizers, Hunter, along with Texas Ranger captain Samuel A. McMurry and others, went to Dallas to quickly transfer the men from the arriving train to one that transported them west to Thurber. Once in Thurber, Texas Rangers guarded the men. Despite these tense beginnings, Black and White miners worked alongside each other several years later, even though legal integration was decades away. (Courtesy of the Thurber Collection, WKGC.)

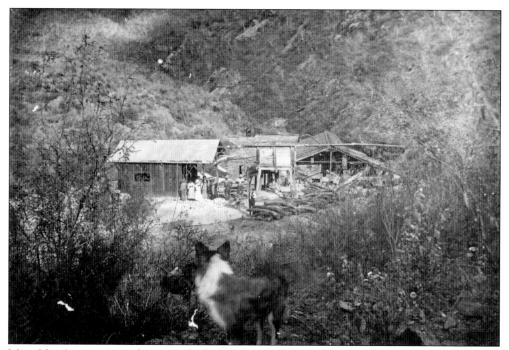

Mine No. 6, approximately one-and-a-half miles southwest of town and somewhat understated, was 95 feet deep with a coal seam thickness of 16 to 28 inches. It began operations in 1893 and closed in 1900 due to poor conditions in the mine, including excessive moisture that was difficult to remove. Miners extracted almost 373,000 tons before it closed. (Courtesy of the Southwest Collection, Texas Tech.)

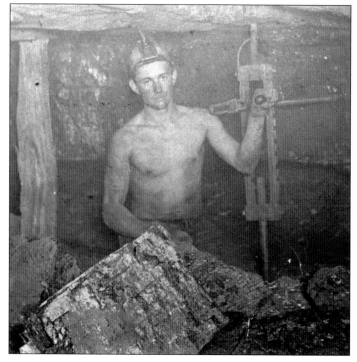

J.C. Collins, like most miners, used a drill to break the coal away from the vein. This image shows the use of the pillar-and-stall method at Thurber. The stall was the room created after coal had been extracted. The pillars, the very lifeline of the miners who worked underground, initially came from timber on land near Thurber, and later from land secured by the Texas & Pacific Coal Company. The sedimentary layering of bituminous coal is visible in the large piece in the foreground. (Courtesy of the Southwest Collection, Texas Tech.)

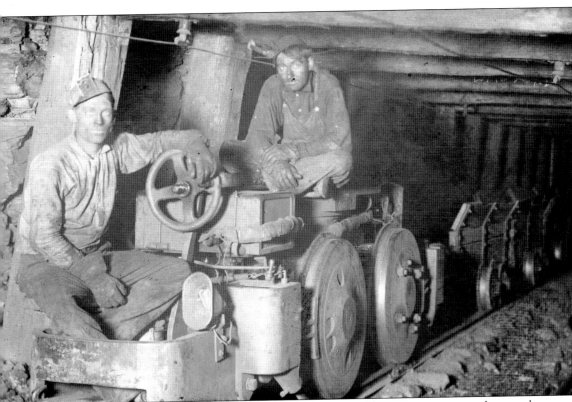

Driving mine carts in low tunnels required constant attention. The engine men wore gloves and headgear with lamps, despite the presence of the lamp at the front of the engine and overhead electric lines for lights. Coal that fell from the carts is scattered on the ground. Both men are covered with the dust that was a constant in the tunnels. In March 1907, Henry Walters jumped off the rail track in Mine No. 5 and was killed when the motor jumped the track. (Courtesy of the Copeland Collection, WKGC.)

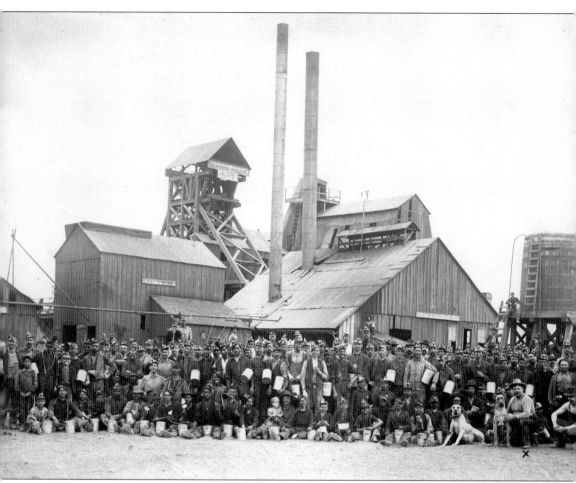

Mine No. 7 was known as "Queen Bess." Taken on May 17, 1901, this image contains all of the elemental buildings of a mine, including, from left to right, the blacksmith shop, the fan house, the boiler and engine room, and the water tower. Judging by the dirt on the faces and clothes of these miners, this photograph was taken at the end of a shift. Many of the miners wore safety hats with oil lamps affixed and have their lunch pails with them. With 1.2 million tons extracted in its 12 years of existence, it was another of the company's top-producing mines. It was the first mine in Texas to have electric means to haul coal out instead of mules and was the closest to the town center, making the ride to and from work shorter for the men who worked there. Young boys also worked in this mine, including those in the front with whips to drive the mules. Two large dogs (right) are also in the image, one sitting with the pit boss (at right, with X). (Courtesy of the Lorenz Collection, WKGC.)

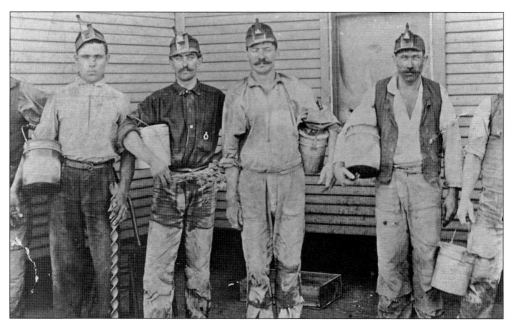

Standing in line to go to work in the pits, men in semiclean cloths—the three on the left with additional cover-ups on their trousers—carry their lunch pails and a large drill bit, and all wear hats with small oil lamps attached. Men who worked the pits generally came from Europe, Mexico, or were Black, which was a sharp contrast to those employed at the brickyard. (Courtesy of the Bida Collection, WKGC.)

Pictured is a portion of the 1905 Sanborn Map Company's detail of the mine locations and Mine No. 7. These detailed maps were used for insurance purposes and provided notations describing building materials, measurements, addresses, purpose, and other information. This one shows that the tipple and adjoining structures were 100 percent wood, whereas the other buildings were metal clad. There was a brick shaft inside the hoisting building with a 130-horsepower engine, and south of that was a 20,000-gallon water tower at an 18-foot elevation. The mine had a fan house, a blacksmith shop, a second engine house, and a repair shop. The 157-foot shaft and coal scales were inside the tipple structure. Extra detail shows the railroad lines, including the one that went through the bin and screen room. (Courtesy of the Library of Congress.)

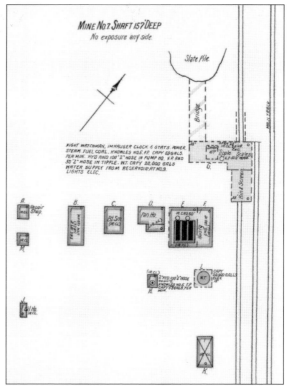

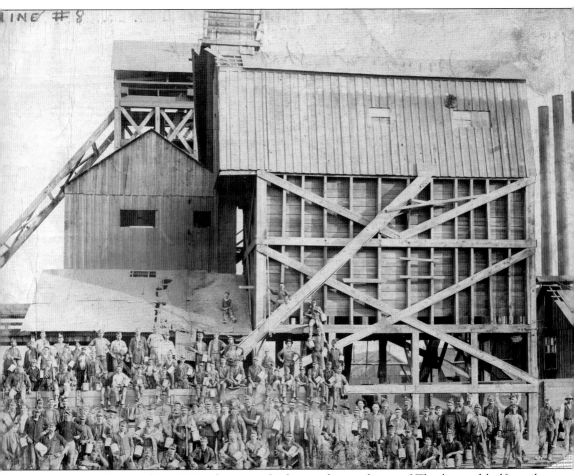

Mine No. 8 opened in 1895 and was nearly three miles northwest of Thurber and half a mile west of Mine No. 7. With a vein ranging from 26 to 30 inches thick, it produced around 400 tons on a daily basis. The miners, some coated in coal dust and others clean, varied from young boys sitting on the wall to older men on the ground at center. All but the one Black man at far right were White. (Courtesy of the Miles Hart Collection, Haley Library.)

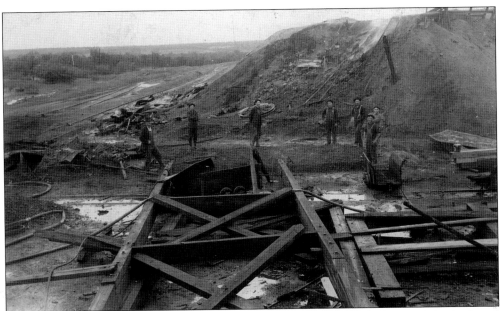

Mine No. 8 suffered a catastrophic fire on June 3, 1904, which completely destroyed the tipple and spread below into the mine. When the structural timbers burned, the mine partially collapsed. As the fire- and smoke-filled mine continued to burn, miners and firefighters went below to try to extinguish the flames. This failed, so the mine was sealed for two weeks. Air was then forced into the mine to provide men with oxygen while they crawled in and sprayed water on the burning timbers. They eventually arrived at the burning powder house and successfully doused 30 kegs of gunpowder with water to stop them from igniting. This water became so heated that the men had to abandon their efforts. The fire was extinguished the following day. After the fire, timbers from the boiler room fell on two men, Henry Long and Ed Thomas, and killed them. Saved, however, were the dynamo engine rooms and a fan. As a reward, the company paid the surviving men top wages and bought them new suits. (Both, courtesy of the Lorenz Collection, WKGC.)

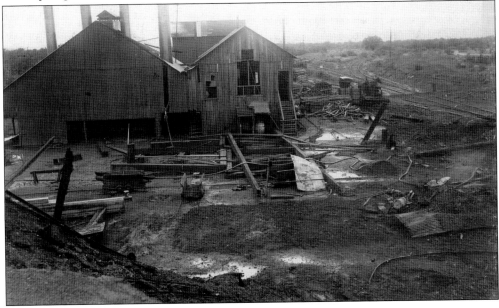

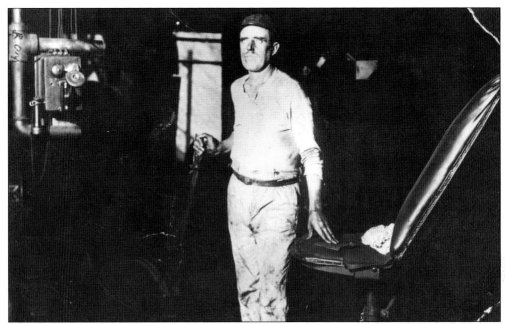

Jim Parsons was the cage operator at Mine No. 8. Born in Kansas in 1871, he and his wife, Willie, who was born in Texas, raised six children in Thurber. Demonstrating upward mobility in the company town, Parsons worked below ground in 1900, but by 1910, he was an engineer and worked in the engine room. Running the cage came with the utmost responsibility. Joe Cobeli somehow fell from the cage as it made its way to the surface in December 1893, and James Nichols, pit boss at No. 10 Mine, was crushed to death by the cage in February 1907. (Courtesy of the Lorenz Collection, WKGC.)

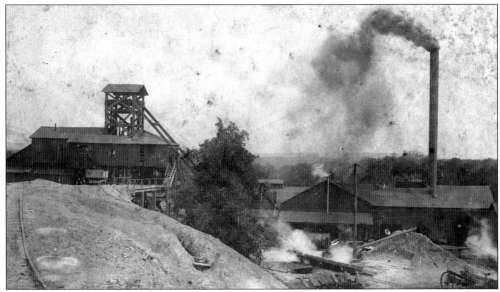

The mining process included removing slate and other waste products with the coal. Train cars exited the mines and went to different areas—coal to the tipple and slate and waste to the dump. Before steam hoisting engines delivered waste products from the mines, mules hauled it all. This slate and waste dump from one of the early mines is flat; those created after the introduction of steam were conical. (Courtesy of the Lorenz Collection, WKGC.)

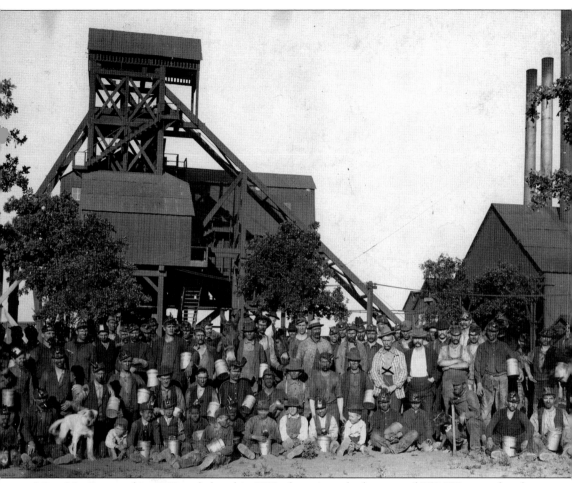

Mine No. 9 opened in 1899 and closed in 1911 after miners had extracted 950,000 tons of coal. At a depth of 190 feet, the coal varied in thickness from 24 to 28 inches. The biggest challenge with No. 9, as with No. 12, was the northwest-to-southwest diagonal fault that was located inside the mine. This made mining particularly challenging and cost prohibitive in the southern and western regions of the mine because they were not on the same level. (Courtesy of the Lorenz Collection, WKGC.)

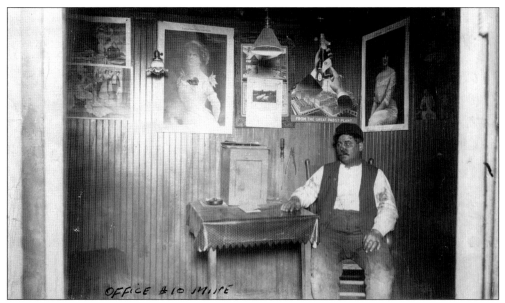

A man sits in the office of Mine No. 10. Decorated with posters of women and beer, this was probably not a room many of Thurber's women entered. The same man is featured in several photographs from No. 10, indicating that he was either the boss or the assistant pit boss. (Courtesy of the Lorenz Collection, WKGC.)

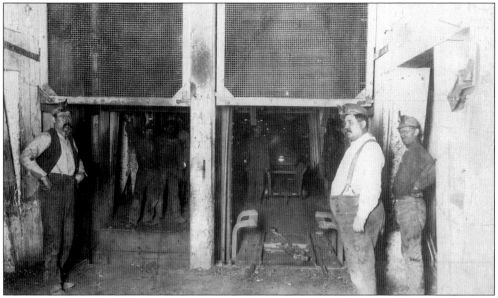

The entrance to No. 10 included an elevator, known as the cage, on the left and a coal cart ramp on the right. The cage took the miners into the pits and brought them back at the end of their shifts. The soot-covered men in the cage illustrate the lack of lung protection that miners faced. Respiratory problems, including black lung (pneumoconiosis), were recorded as causes of death for many of Thurber's miners. Mine No. 10 was 235 feet deep and operated between 1901 and 1926. By July 1, 1913, it had produced 1.4 million tons of coal, which was the most from one mine in the entire state. Located three miles northwest of Thurber, it had an output of 700 tons per day in 1913. (Courtesy of the Lorenz Collection, WKGC.)

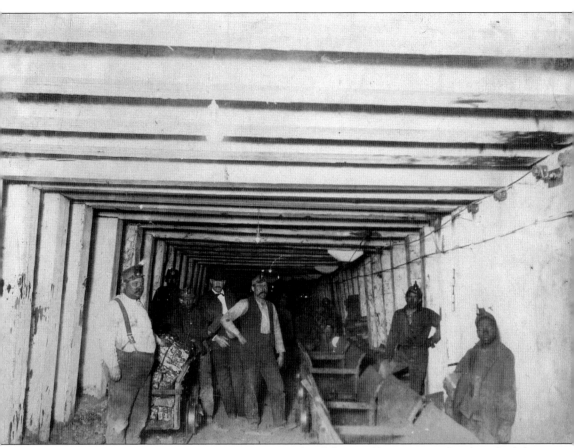

Inside the mine shaft of Mine No. 10, men pose with a full cart of large pieces of coal on the left and several empty carts in front of men deeper inside the shaft on the right. The fourth man from left may have been there to inspect the mine, as he is dressed in clothing more appropriate for management. A young African American miner stands at far right. Thick timber beams and studs spaced approximately two feet apart support the roof and walls, and electric lights are attached to the ceiling. (Courtesy of the Lorenz Collection, WKGC.)

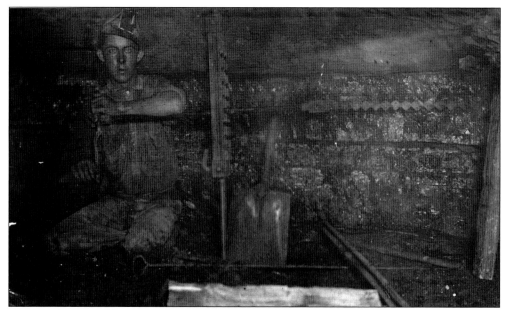

Because the vein of bituminous coal was less than four feet wide, coal miners saved time by not digging tall tunnels to work in. Mines were cramped, contained air heavy with coal dust and other contaminants, and were extremely hot. Miners often worked on their sides. Jim Treece, shown here in 1910, hand drilled into the vein while his jack supported the roof from a cave-in. The company provided a doctor to keep miners healthy enough to work as much as possible. In the beginning, employees paid 50¢, and then a dollar, into a hospital fund each month. By the mid-1920s, fees were only collected by those who wanted to pay. (Courtesy of the Lorenz Collection, WKGC.)

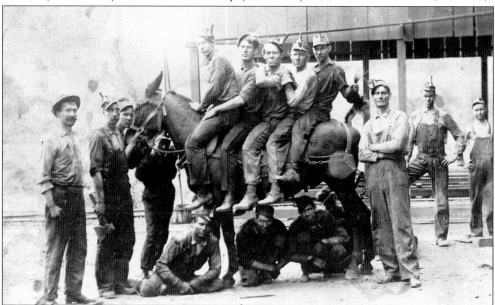

Mules made coal mining possible. Their strength brought the coal and other products to the surface, making it possible for the men to focus on their work. It was not unusual for mules to be taken underground and left there for years, although it is unclear if this happened in Thurber. (Courtesy of the Southwest Collection, Texas Tech.)

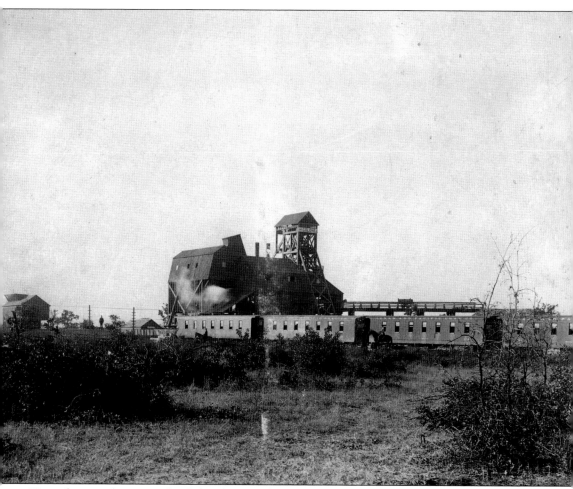

Here, the mine known as the Colonel Hunter has not yet been identified by number in Thurber. Named after R.D. Hunter, it would have used the same long wall method as the rest of the mines. This required four or more tunnels to extend from a centrally located shaft several hundred feet deep, creating an underground system that resembled a wheel with spokes. As the miners dug farther to follow the coal vein, they covered approximately a square mile, or 640 acres. Within 10 years of the company's existence at Thurber, there were approximately 1,500 miners working underground in different shifts. At top right, over the railcars, is a bridge with an empty coal cart going across. The mine was next to the stable, which might explain the two men on horseback in front of the Texas & Pacific Coal Company railcars. (Courtesy of the Lorenz Collection, WKGC.)

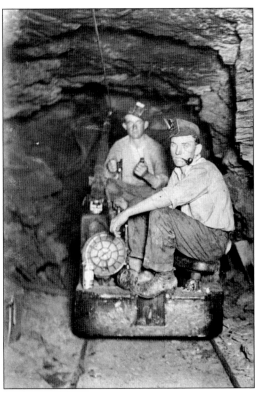

Electric pit cars were put into use after the company discontinued the use of mules and donkeys in the mines. Both men in this image are holding different controls, and the one in front sits on what was surely a very uncomfortable seat after a long shift. Both miners have pit lamps on their heads; however, neither is lit. (Courtesy of the Bennett Collection, WKGC.)

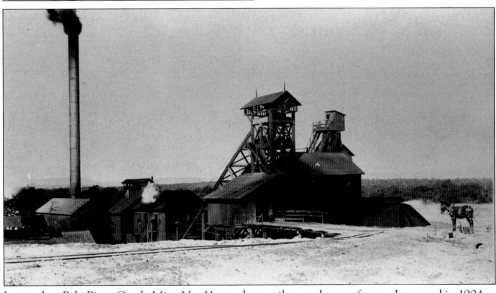

Located on Palo Pinto Creek, Mine No. 11 was three miles northwest of town. It opened in 1904 as one of the company's four deepest mines at 194 feet, with pit boss Joseph Hopkins in charge. The average coal seam varied from a desirable 24 to 28 inches thick but had to be mined by machines in the western quarter due to prohibitive conditions, and pick mined elsewhere. No. 11's location on the Palo Pinto Creek may have contributed to the west surface area at the face. As with the other mines, a night watchman was present and used a six-station Imhauser clock to keep precise track of where and when he patrolled. (Courtesy of the Southwest Collection, Texas Tech.)

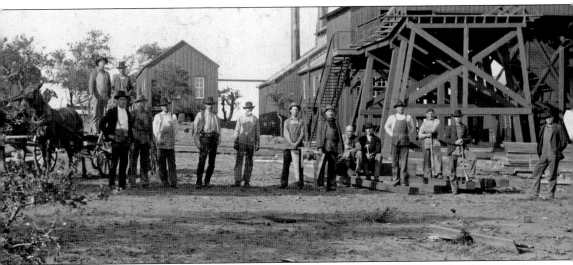

The focus of the mines is generally the people who worked in them every day, but it took carpenters to build all of the structures to make that work possible. The amount of work they did is staggering—from building each of the mines and all of the buildings that surrounded them to the construction of all of the houses, churches, and buildings in town. These men standing at the almost completed Mine No. 11, nicknamed "Little Sister" after Pres. Edgar L. Marston's daughter Jeannie Fances, hold axes, saws, squares, and hammers as they stand next to an enormous stack of wood ready to be used. There are no other working people in the image, and everything appears crisp and clean. (Courtesy of the Lorenz Collection, WKGC.)

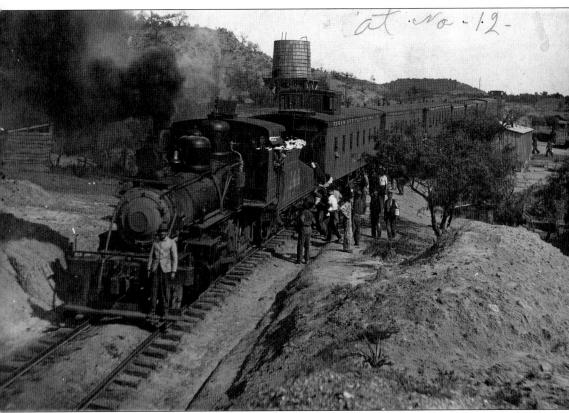

Mine No. 12 opened in 1906 at a depth of 110 feet and was run by pit boss Robert Stuart. The elevated water tower (center) overlooked the rest of the mine. It was a steam-powered mine, with electricity for lighting and coal for fuel. Like Mine No. 11, it was also on Palo Pinto Creek and faced challenges with water in the mine that was difficult to remove. It shared the same diagonal fault as Mine No. 9, so a good portion of the coal had been thrust to a lower level when the land shifted. Weight of the coal in Thurber varied according to the mine, and No. 12 was heavy due to water content, meaning that these miners had to load less coal to make a ton. The company train, the *Black Diamond*, is also pictured here. Miners paid a dollar or more per month to ride it to work from two stations in town. (Courtesy of the Southwest Collection, Texas Tech.)

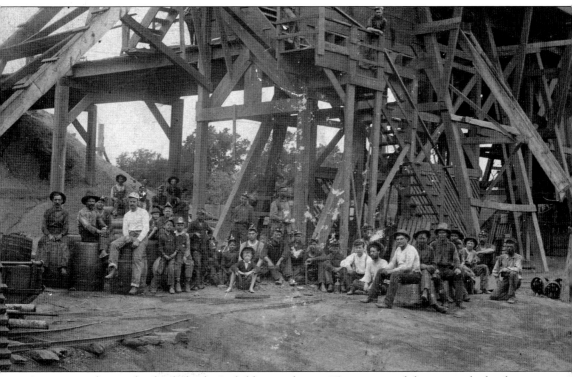

Approximately two-thirds of Thurber's children under age 15 or younger did not attend school at the turn of the 20th century, despite the availability of many different schools. Mining was not just a man's job; children as young as six worked in the mines in 1900. By 1910, fewer children appeared to be working in the mines, and those who did were between 14 and 16 and were largely from Italy or Mexico. Breaker boys, as they were called, broke down the larger pieces of coal to create more uniform sizes as they removed unwanted material, like clay or dirt; they also worked inside the mines. With no regulation to protect their health, children in the mining industry suffered from the same dust-related diseases as the adults. Causes of death for children born in Thurber include lung-related illnesses. At least eight children in this image wear headgear with lamps attached, suggesting that they worked in the pits. (Courtesy of the Lorenz Collection, WKGC.)

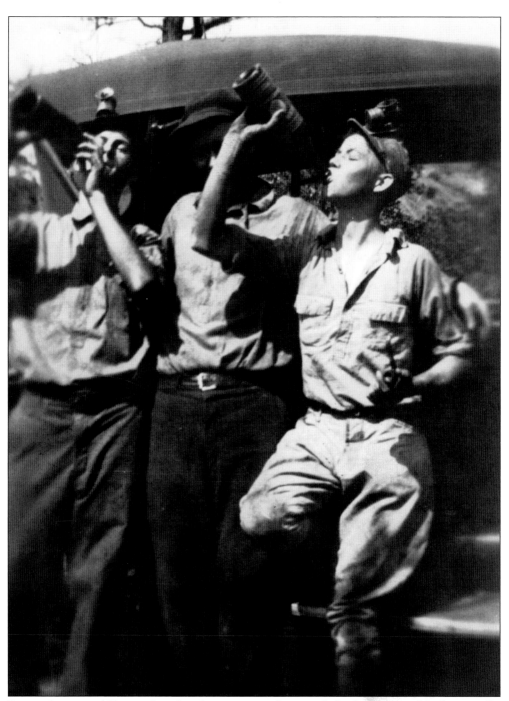

Beer and wine could be purchased in the company saloons and also from some of the home stills, which were illegal. Erath County sheriffs arrested several men throughout the years for operating stills, violating local options, selling to minors, and various other alcohol-related offences, but it is not certain that those arrests were against Thurberites. Either way, these miners probably were not thinking about that as they enjoyed a beer after what must have been a very hard day in the pits. (Courtesy of the Copeland Collection, WKGC.)

Two

THURBER BRICK

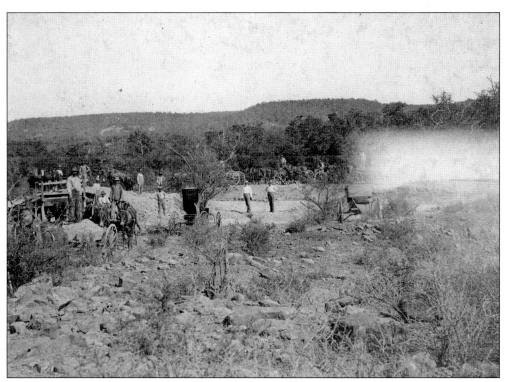

Before the brick plant opened, R.D. Hunter made an attempt at selling gray sandstone from a rock quarry on the company's property. This venture failed, so he tried to produce coke with Thurber coal; however, his was not a success either. Hunter looked for another way to diversify the company in a region where others were making bricks. (Courtesy of the Lorenz Collection, WKGC.)

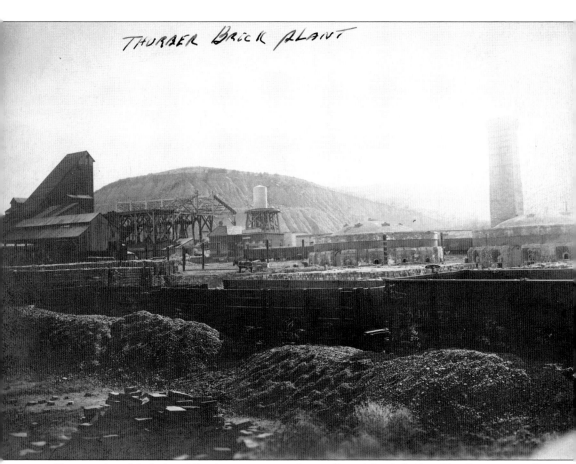

THURBER BRICK PLANT

Test samples of shale from Thurber were sent to James Green's Leclede Fire Clay Company in St. Louis. Results showed that it was suitable for the production of vitrified brick and floor and roof tiles. Incorporated on February 23, 1897, separately from the Texas & Pacific Coal Company, the Green and Hunter Brick Company had a capital stock of $100,000; primary investors were Hunter, Green, Moses Rumsey, John C. Dods, and also Shadrick Mims and Robert H. Ward, who were directors at Texas & Pacific Coal Company. The charter granted the brick company the authority to construct an electric light and power plant, dams, and rail lines to join the Texas & Pacific and any other rail company that could enter the region. It was the most advanced facility in the Southwest at the time. To ensure that the brick factory had the best possible beginning, James Green provided experts from his plant in St. Louis. These men advised on the factory's layout, helped install machinery, and taught others how to execute the brickmaking process. By July 24, 1897, the plant was producing 30,000 bricks on a daily basis. (Courtesy of the Miles Hart Collection, Haley Library.)

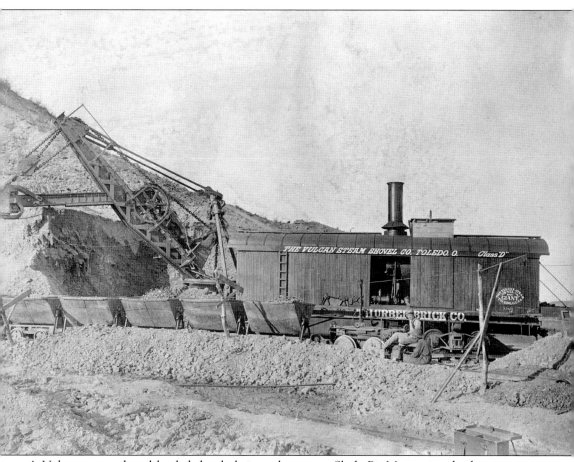

A Vulcan steam shovel loaded the shale into the cars at Shale Pit Mountain, also known as Steam Shovel Mountain. Located in Toledo, Ohio, Vulcan manufactured two popular brands of shovels, the Little Giant and Giant models. The Thurber plant used the Giant, which was one of the largest shovels made. Made to travel on train tracks, it had a 20-foot cast-steel crane with a 200-degree swinging capacity and a 19-foot radius that could rotate toward the shale, dig into the mountain, and then swing back and unload in a waiting wagon. (Courtesy of the Lorenz Collection, WKGC.)

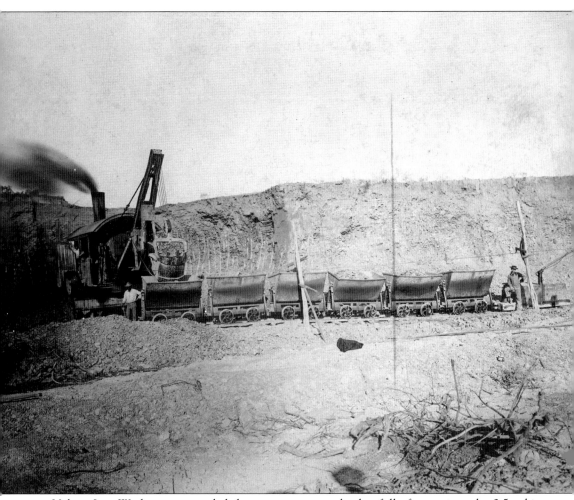

Vulcan Iron Works recommended that a man empty a bucket full of water into the 2.5-cubic-yard bucket before each use to stop material sticking to the sides. Constructed out of I-beams, 10 feet wide by 35 feet long, with reversible engines with two steam cylinders on the thrusting and swinging mechanisms, and a friction clutch, this machine ran at approximately five miles per hour, which was considerably faster than two men shoveling shale. (Courtesy of the Lorenz Collection, WKGC.)

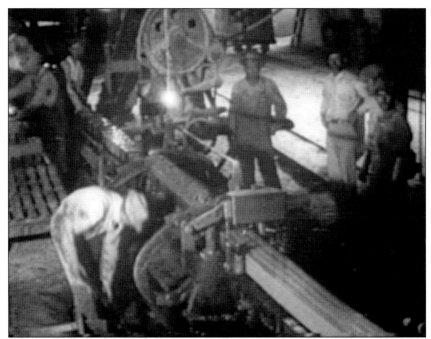

In 1898, Green and Hunter made a decision that had an enormous impact on the future of the plant—they began making vitrified paving bricks. They began using the stiff mud method, rather than pressing clay into bricks with hydraulic power, which added water to powdered clay from the crushed shale. Feeding the mix through an extrusion mold, a ribbon of clay traveled on a conveyor belt to a wire cutting machine that cut it into uniform-sized bricks. These images are from a video the company made about this process; no others are known to exist. Above is the ribbon, and below is the cutting machine. (Both, courtesy of the Bennett Collection, WKGC.)

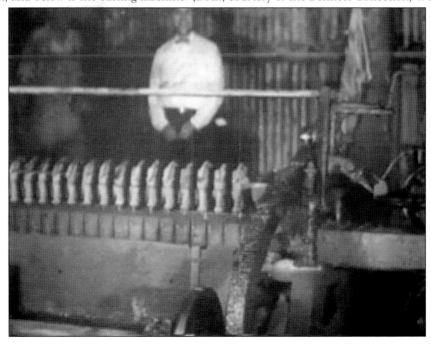

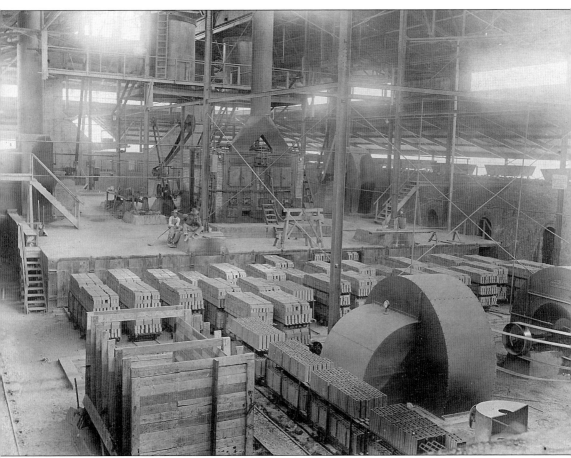

Offbearers hand loaded green bricks from conveyor belts onto rail carts. From there, the bricks headed to the steam dryers before they were fired so they did not explode due to rapid moisture loss. The steam dryer area required a constant temperature from furnaces that were first heated by pea and nut coal and then gas. This image shows several of the 32 sets of tracks the loaded carts rested on during the two-to-three-day process. (Courtesy of the Murphey Collection, WKGC.)

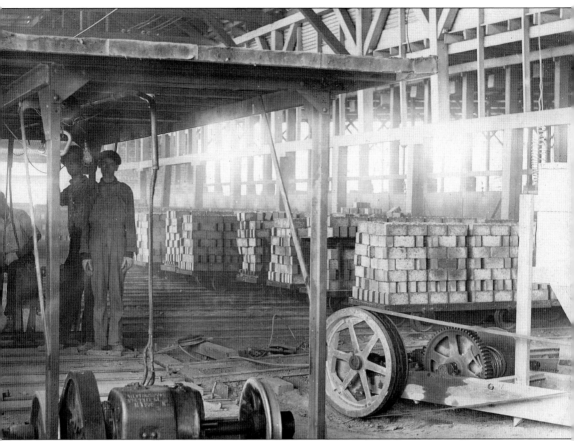

After the drying process, the bricks headed to the kilns. Using rail tracks, the carts could travel easily to their destination. These young men on an empty cart appear to be waiting for another load of kiln-bound bricks to transport. They wore heavy, oversized gloves to protect their hands. (Courtesy of the Miles Hart, Haley Library.)

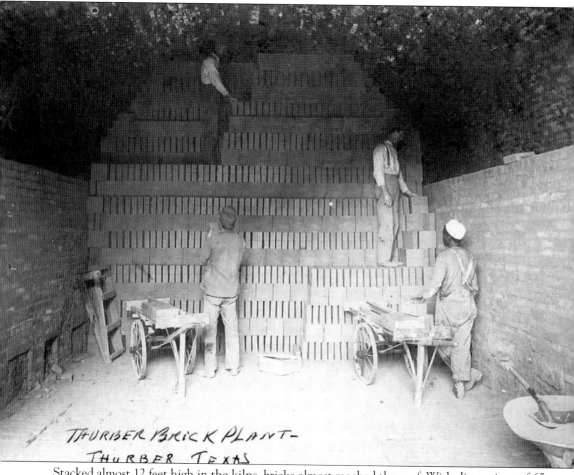

THURBER BRICK PLANT—
THURBER TEXAS

Stacked almost 12 feet high in the kilns, bricks almost reached the roof. With dimensions of 65 to 110 feet long and 18 feet wide, each kiln held close to 1,000 bricks. During the 30-day process, increased heat was applied until it attained a temperature of 1,500 to 1,600 degrees Fahrenheit. At this point, white smoke coming from the kilns turned blue as carbon and sulphur escaped from the chimney. At the end of this phase the smoke turned clear, and the temperature was increased to approximately 1,960 degrees for six days to vitrify the brick. The cooling period lasted four to five days before the bricks were removed. (Courtesy of WKGC.)

DAILY COAL REPORT
TEXAS & PACIFIC COAL COMPANY
THURBER, TEXAS, 2/19th 191 2

FORM 115 9-12-2M

		LUMP		NUT		PEA		REMARKS
		CARS	TONS	CARS	TONS	CARS	TONS	
MINED: Mine No. 8	8 trs	8	292.05	1	20.75		10.00	
Mine No. 10	2 ,,	1	42.05		5.00		5.00	
Mine No. 11	8 ,,	13	445.45				12.00	
Mine No. 12	,,	12	412.55	1	26.40	1	29.70	
Mine No. 1	,,	8	343.10			1	33.00	
Mine No. 2	,,	3	729.30				6.00	
Mine No. 3	,,	2	74.95				3.00	

The company did not pay miners for pea (less than one inch) or nut (between one and two inches) coal because they said it was too small for the railroads to use. This was a serious bone of contention with miners because they were not getting paid to mine it. Hunter sold this coal to George Bennett, owner of the Acme Brick Company in Parker County, which opened in 1891. In March 1897, less than a month after the plant opened, Hunter raised the cost to a prohibitive level, so Bennett stopped buying from him. This daily coal report from February 19, 1913, shows the amount of coal, including pea and nut, from seven of the mines. (Courtesy of the Tucker Collection, WKGC.)

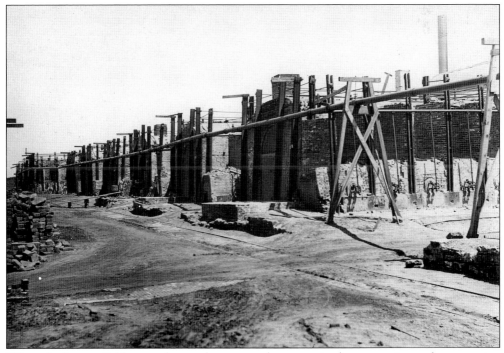

When the Ranger fields started to produce, natural gas was piped to processing and compression plants. Gas was piped to Thurber from Plant No. 2 in Eastland County and used to heat homes, businesses, and the brick kilns. Pipe on the X-braced stands delivered gas to the kilns. Smaller pipes ran gas directly to each of the furnaces at the bottom, which made these down-draft kilns. This model of kiln was more efficient than the updraft that was formerly in use, as it had a better distribution of heat and created higher-quality vitrified pavers. (Courtesy of the Miles Hart Collection, Haley Library.)

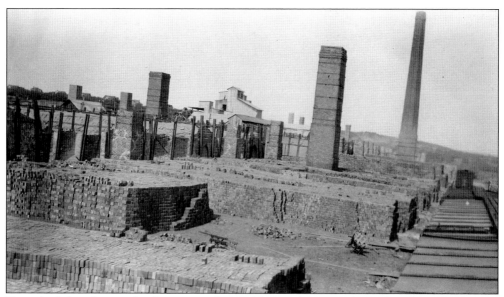

From the kilns, the new bricks went to the yard before they were shipped to their destination. Some jobs called for millions of bricks, like paving the streets of downtown Fort Worth or Houston, and with a processing time of over a month, there had to be enough to fill orders. (Courtesy of the Miles Hart Collection, Haley Library.)

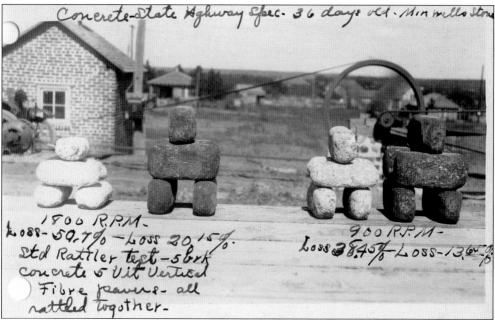

Thurber Brick was recognized for its quality and ability to weather the elements. Quality was tested on a regular basis, as there was a lot riding on it. State highways had specifications that had to be met, which Thurber bricks did. Concrete and vitrified bricks were placed in a rattler, a rotating drum made with steel ribs, to test strength and durability. Two tests were conducted: one at 1,800 rotations per minute and the other at 900. Thurber brick rated better than the concrete, and was used throughout the state to pave highways and roads. The rattler also produced a line of rounded bricks sold by the company. (Courtesy of the Miles Hart Collection, Haley Library.)

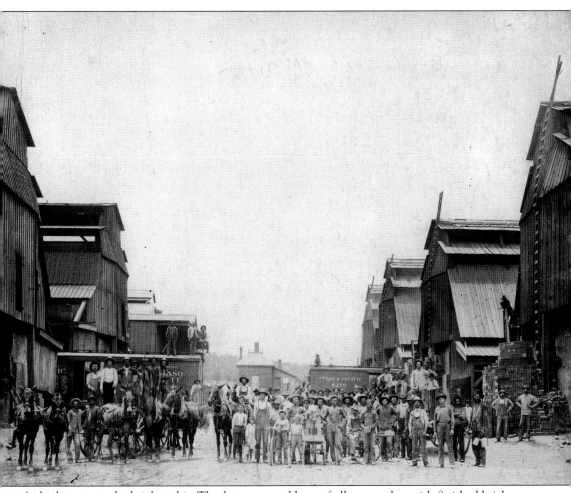

At high noon at the brickyard in Thurber, men and boys of all ages gather with finished bricks, surrounded by the six largest kilns at the yard. Kilns Nos. 1 and 2 are on the left, and Nos. 3, 4, 5, and 6 are on the right. Behind the men on top of the left railcar was Kiln A, the first of 12 others used for curing. The two Texas & Pacific railroad cars were on one of the four rail switches that traversed the brickyard, facilitating transportation of the finished product to waiting markets. The office, where the vault was located, is at center rear. The date of the photograph is unknown, but it is believed to have been taken in the mid-1920s when the brickyard was operating at peak level. (Courtesy of the Lorenz Collection, WKGC.)

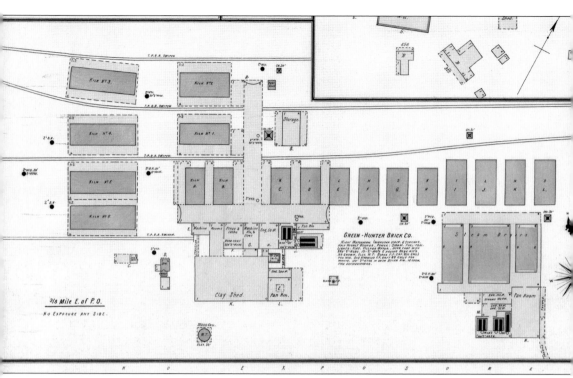

Sanborn Insurance maps from January 1905 provide a detailed layout of the plant. The setting for the previous photograph was approximately where the dot is in the middle of the kilns on the left of this image. Kiln A begins the horizontal row to Kiln S. Below, on the right, are the steam dryers, pan room, and dynamo. The clay shed is at bottom center. A night watchman provided security, and 14 chemical fire extinguishers were stationed throughout. (Courtesy of the Library of Congress.)

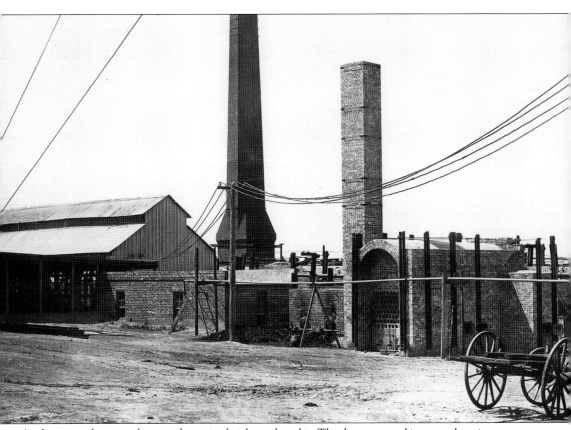

As the pavers became the most lucrative brick produced in Thurber, new and improved equipment was added, including auxiliary furnaces like this one for Drier No. 2, which was the only one of its kind in the South. (Courtesy of the Miles Hart Collection, Haley Library.)

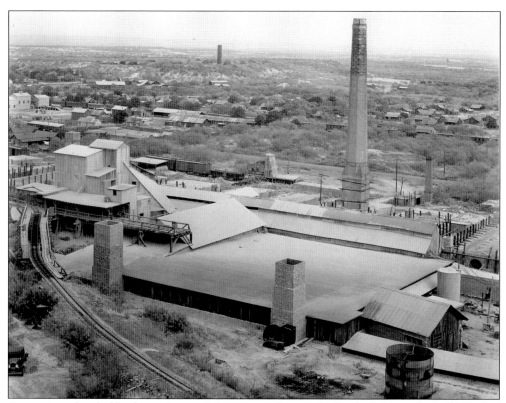

Approximately a half mile southeast of the center of town, the brick plant overlooked Thurber and, within a few years, Big Lake on the east. When the plant first opened, mules labored to haul material from shale deposits nearby, but by 1903, better-quality shale from Shale Pit Mountain was used. These mules were soon replaced with electric and then gas-fueled cars on a rail line that went directly to the plant. (Both, courtesy of the Miles Hart Collection, Haley Library.)

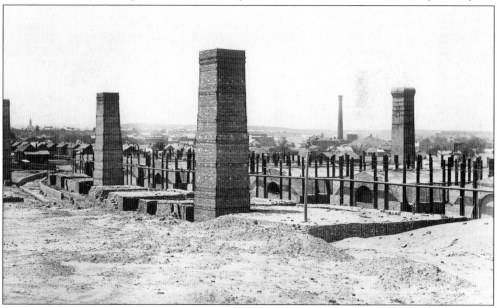

Before the highway system began in Texas in the early 1900s, roads often meandered where they were most needed. Long-distance travel challenged people, wagons, and early vehicles, and rail was the preferred method to go a long distance. By 1904, Texas had 121,409 miles of roads, but only 2,128 were paved with gravel and dirt. Good Roads legislation and lobbying efforts of the Federation of Women's Clubs pushing for a Texas highway department brought significant change to Texas in 1910, and nearly $9 million in bonds began the push for highways and better streets. Before the paving process could happen, road crews smoothed the surface and prepared it for brick. This method continued throughout the 1910s and 1920s with added machinery by different contractors, like the Jones Construction Company, as it was developed. (Both, courtesy of the Miles Hart Collection, Haley Library.)

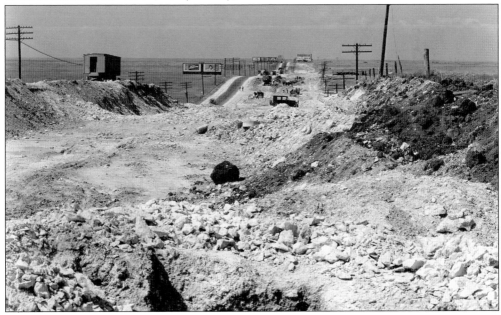

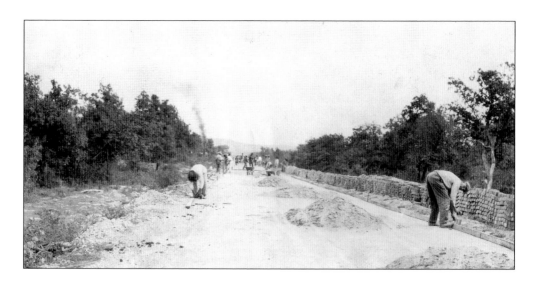

Brick by brick, yard by yard, mile by mile, it was all done by hand. Each paver weighed eight pounds, and each bricklayer handled thousands of bricks as they bent over for hours each day. This stretch of road going to Eastland County still has Thurber bricks as its base, but now, it is covered with asphalt like most of the other roads once paved the same way. Smooth and dependable surfaces contributed to safety and decreased travel time, all as the number of vehicles on the roads increased to nearly 140,000. (Both, courtesy of the Miles Hart Collection, Haley Library.)

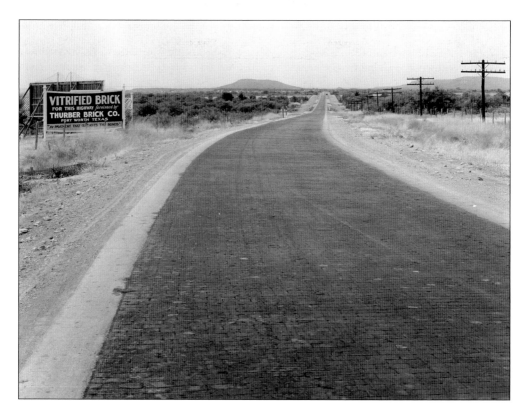

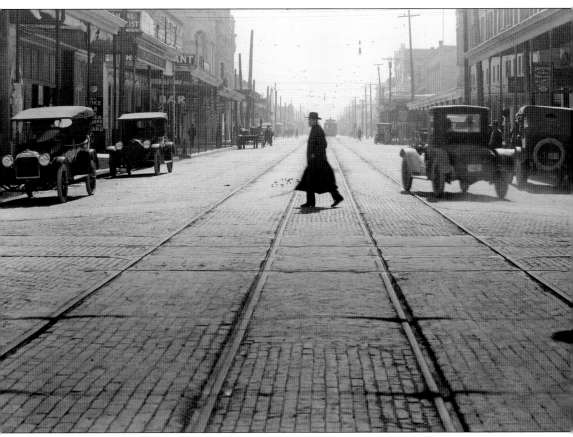

In Austin, Brown and Dabney ordered an extra 100,000 pavers in February 1905, touting them as the best-made bricks and perfectly suited for Congress Avenue and other busy streets in the capital city. Three years later, Houston ordered a million bricks that would be transported in 150 railroad cars to pave 16 of its city streets. This trend continued throughout the decade and into the next. In October 1911, Galveston opened bids to see who would lay 4,900 yards of Thurber's vitrified pavers on the arch bridge causeway. Six different contractors placed their bids with different brick suppliers. J.C. Kelso won the contract at $1.90 per square yard, and N.L. Vermilya, the assistant general manager at the Thurber Brick Company, promised prompt delivery of material. The causeway was not the only surface covered with Thurber's bricks. The man in this photograph crosses another of Galveston's busy streets. At full operation, the brick plant produced up to 80,000 bricks daily. By the time the plant closed in 1930, it had produced millions of bricks in 35 styles. (Courtesy of the Miles Hart Collection, Haley Library.)

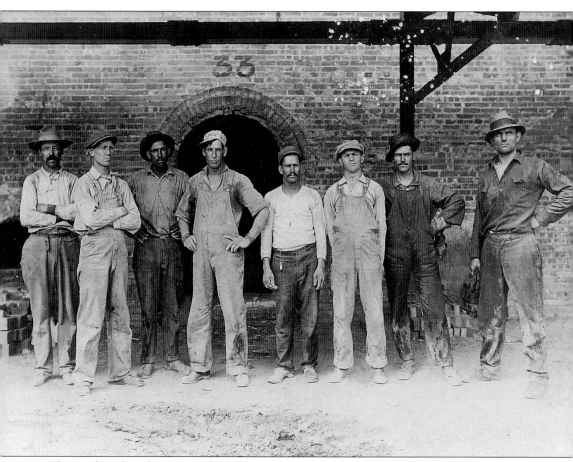

The number of employees varied throughout the years, primarily due to the purchase of improved equipment. When the Vulcan steam shovel began digging the shale, electric rail lines helped transport bricks, and gas fueled the kilns, the number of employees dropped from around 200, then fluctuated for years as the operation was fine-tuned. By 1927, fewer than 100 people were required to make millions of bricks. (Courtesy of the Miles Hart Collection, Haley Library.)

Three

MANAGEMENT

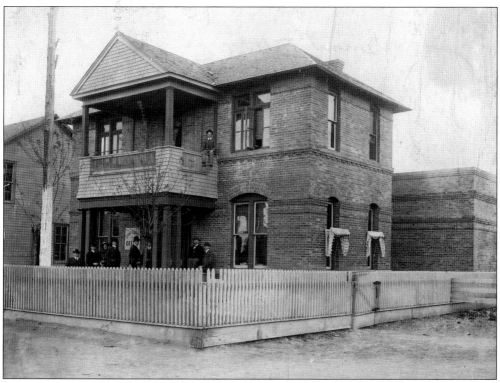

Upper management seldom lived in Thurber during the coal and brick years, residing instead in Fort Worth or New York City. Most of the communication between the different locations was conducted by telegraph or letters. The company's offices employed a full-time staff in Thurber, where most of the local records were kept in this handsome two-story brick building. (Courtesy of the Lorenz Collection, WKGC.)

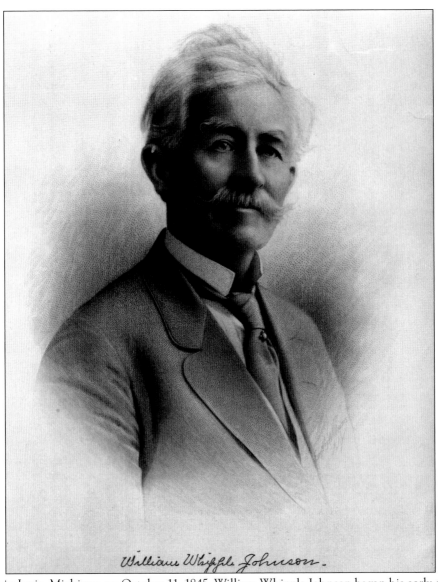

William Whipple Johnson.

Born in Ionia, Michigan, on October 11, 1845, William Whipple Johnson began his early career in real estate and lumber. He and his father went into business together, only to face ruin due to the Panic of 1873. With everything to gain, he moved to Corsicana, Texas, in 1878 and then Strawn a few years later. Johnson and his brother Harvey raised horses and cattle, sold railroad ties to the T&P Railroad and cedar fence posts to local ranchers, and also sold supplies from a tent to railroad workers. On a trip through Erath County, Johnson met an unhappy man having trouble digging a water well. Johnson recognized the value of the black rock thwarting the digging process, and the pecuniary opportunities it represented if the T&P Railroad would build a spur to the location from the main line less than three miles away. He secured a contract with T&P officials, and the Johnson brothers purchased the 2,302.5-acre Pedro Herrera Survey for $2,500 in October 1886. The following year, they opened the Johnson Coal Mining Company and then the Palo Pinto Coal Mining Company. At 35 years old, Harvey died in 1887, leaving William as the sole owner. He sold the mines to a group of New York investors in 1888 and moved to Fort Worth. (Courtesy of WKGC.)

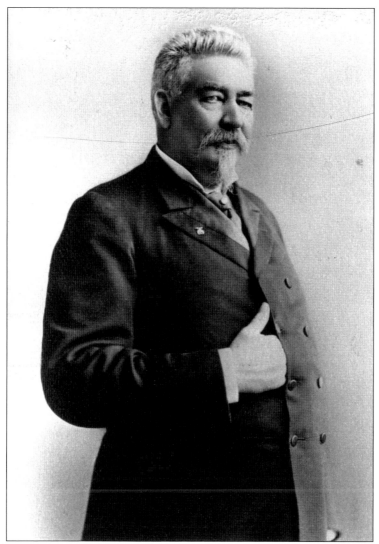

Robert Dickie Hunter was born April 3, 1833, in Ayrshire, Scotland. By his 10th birthday, his family had moved to Central Illinois and were farmers. Hunter went to Russell Gulch, Colorado, to mine for gold in 1859, where he panned enough gold to purchase a quartz mill. A brief foray in Arizona followed but then he moved back to Colorado to the San Juan Valley, where he found the Putnam Lode in a region devoid of easy access to transportation. In 1864, he moved his family to Missouri and supplied oxen to freighters until the end of the war. He then paid $10,000 in gold for a herd of cattle that brought him $6,000 profit. Hired by the Kansas Pacific Railroad in 1871 to persuade cattlemen to ship their stock to the Kansas City Stockyards, Hunter also worked as a commission agent. The establishment of Hunter, Evans & Company in 1873 continued the commission work and yielded an annual revenue of $500,000 within eight years. Hunter sold his portion of the business in 1887, coincidentally about the time that William W. Johnson asked him for a loan to improve his coal mining operation. Hunter waited until Johnson could no longer support his business and, together with his son-in-law Edgar L. Marston and H.K. Thurber, a New York City grocery supplier, purchased controlling shares in Johnson's company for $48,750 cash and $250,000 in bonds. With this move, Hunter became the president of the newly formed Texas & Pacific Coal Company. (Courtesy of the Miles Hart Collection, Haley Library.)

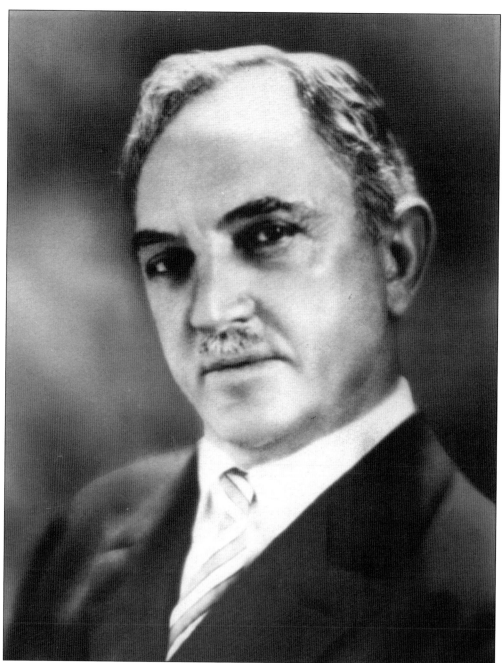

William Knox Gordon was born January 26, 1862, in Spotsylvania County, Virginia. He earned his degree in engineering in Fredericksburg, Virginia. In 1889, Gordon came to Texas to conduct railroad surveys and met R.D. Hunter, who offered him a job managing the coal mines in Thurber. Under Gordon's management, the company thrived as workers and residents gained respect for his management style, which was much more benevolent than that of his predecessor. Gordon lived in Thurber with the people who worked for him, and he got to know many of the families personally. There are very few accounts that portray him as anything other than a fine man and great leader. (Courtesy of the Stiffler Collections, WKGC.)

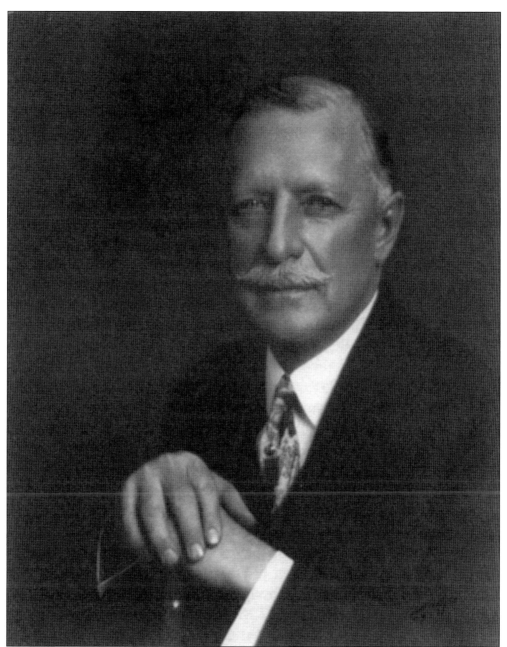

Edgar Lewis Marston, a lawyer and R.D. Hunter's son-in-law, was instrumental in the organization of the Texas & Pacific Coal Company in 1888 and became its president in 1899 when Hunter retired. Under his leadership, coal production nearly doubled, the brick plant produced millions of pavers that went all over Texas, and oil became the main extractive product the company sold. Thurber itself experienced growth, new company businesses helped build greater profits, and new houses provided places for an increased workforce to live. (Courtesy of Hardin-Simmons University.)

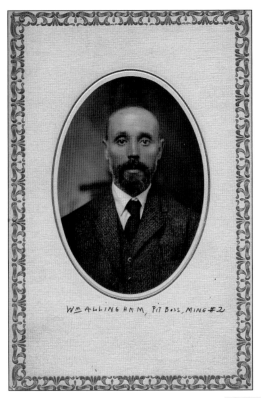

WM ALLINGHRM, PiT B0SS, MINE #2

There were many mine bosses throughout Thurber's history, as each had its own management team. William Allingham was pit boss in new Mine No. 2, which opened in 1909, five miles west of Thurber on Bear Creek. It was the deepest of the Thurber mines at 327 feet. (Courtesy of the Miles Hart Collection, Haley Library.)

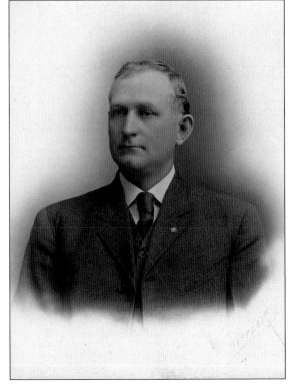

Thomas R. Hall served as the paymaster and cashier for the Texas & Pacific Coal Company. He worked 40 years for the company, issuing pay on the third Saturday of each month until his death in June 1930. He started with the Texas & Pacific Railway Company in 1886 in the engineering department that conducted the initial survey to create the spur into what became Thurber. He joined the T&P Coil Company in 1889 and witnessed almost all of the growth, changes, and eventual demise of its 50 years of existence. (Courtesy of the Miles Hart Collection, Haley Library.)

Mace P. Oyler (or Oiler) served as the pit boss for Mine No. 10. At a time when there was no formal training in the United States for running a mine, foreign knowledge was sought and used. This is reflected in the nationality of many of the pit bosses and their families throughout the company. Daniel Joseph was born in Ohio to Welsh parents, Thomas Strongman moved to the United States from England in 1885, Charles Randle was born in Ohio to an English father and Welsh mother, Thomas Phillips came from Wales, Robert Stewart was from England, and William Frew was born to Scottish parents in Virginia. (Courtesy of the Miles Hart Collection, Haley Library.)

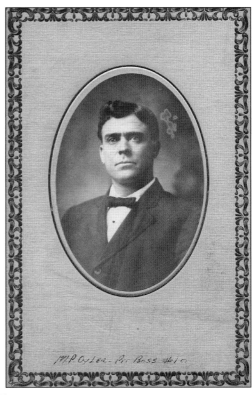

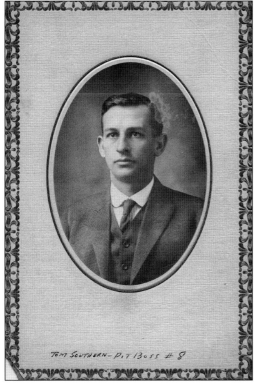

Pit boss Thomas Southern oversaw the daily work that went on in Mine No. 8. Born in Kansas, Southern came to Texas, where he met his wife, Bettie, and had five children. Southern worked as an assistant pit boss in 1910 and later was promoted to full pit boss. (Courtesy of the Miles Hart Collection, Haley Library.)

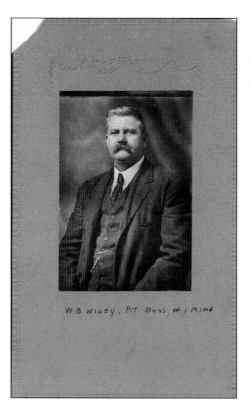

W.B. Wiley served as pit boss to New No. 1, which opened in 1909 with New No. 2. At the time, New No. 1 held the record in Texas for the rapid rate of production, perhaps to Wiley's credit. (Courtesy of the Miles Hart Collection, Haley Library.)

W·B WILEY, PIT BOSS, #1 MINE

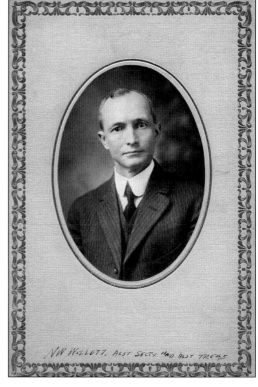

N.W. Willett, from Illinois, began with the company as a cashier and worked his way up to director of the Thurber Brick Company when the transition from Green and Hunter Brick Company took place. By 1920, Willett was the assistant secretary and assistant treasurer for the company. His son N.W. Jr. worked at the battery station, and his daughter Minnie worked as a mail carrier. (Courtesy of the Miles Hart Collection, Haley Library.)

NW WILLETT, ASST SECTY AND ASST TREAS

Arthur H. Miller migrated from Russia and married Laura, a New Yorker. Miller worked as a company manager, while two of his sons, Arthur, an engineer, and Frank, a carpenter, also worked in Thurber. Miller was one of several men who was supported by the people of Erath County and elected to serve as a justice of the peace for Precinct No. 7, which included Thurber. (Courtesy of the Miles Hart Collection, Haley Library.)

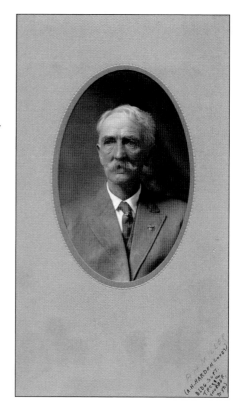

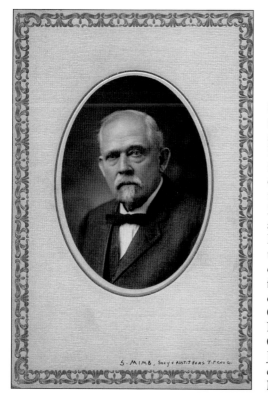

Shadrach Mims began as the secretary of the company but was soon promoted to secretary and assistant treasurer. Mims, born in Alabama on June 6, 1837, attended the Fredonia Military Academy and then college in Summerfield. He enlisted with the Prattville Dragoons, a division of the 3rd Alabama Cavalry, during the Civil War and was present at Shiloh, Chickamauga, Murfreesboro, Missionary Ridge, and throughout the Atlanta campaign. His employment before he moved to Thurber focused on cotton and railroads, including cotton industries Tarlton, Whiting & Co. in Mobile, R.L. Adams & Son in New Orleans, and Moody & Jemison in Galveston and railroad builders Morgan, Jones and Dan Carey, where he was in charge of the finances. (Courtesy of the Miles Hart Collection, Haley Library.)

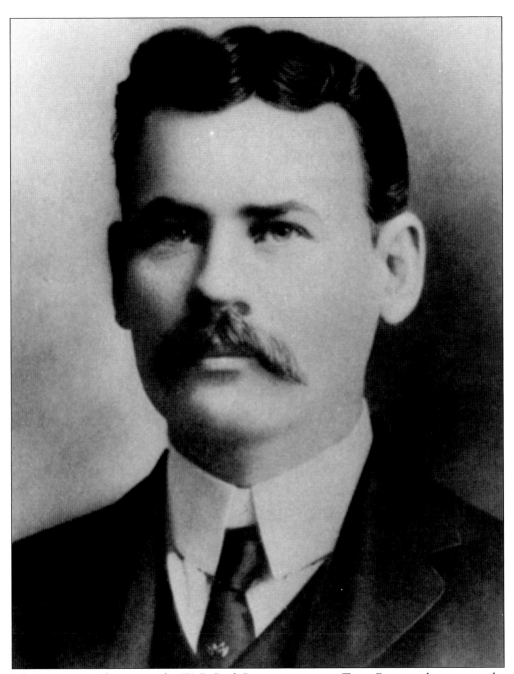

Ed Britton's introduction to the T&P Coal Company was as a Texas Ranger who was sent by Austin during the transition of the Johnson Mines, as many of the miners were striking. Britton was ordered to move from Thurber to Eastland to investigate a cattle rustling problem but was hired by R.D. Hunter to help sink a new mine shaft at the rate of $90 per month. When the mine was drilled, Britton served as its weighmaster, then moved to the check office, and then was promoted to paymaster before Thomas R. Hall took over in 1895. He moved into the position of general storekeeper until March 1904, when he terminated his employment with the company. (Courtesy of the Dick Smith Collection, Tarleton State University.)

Four

UNION

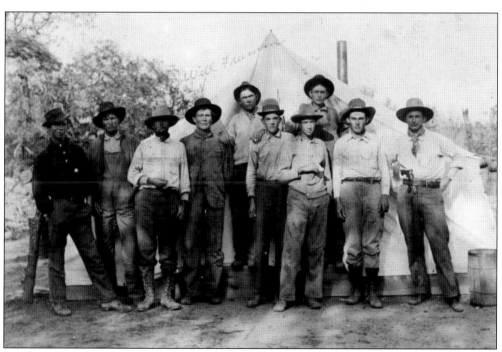

One of R.D. Hunter's first actions as president of the newly formed Texas & Pacific Coal Company was to install a four-strand barbed wire fence around 900 acres and evict every miner striking against his company. He then reduced miners' wages from $1.95 per ton of coal to $1.40 and brought in armed guards to keep scabs and union representatives out of town. On December 12, 1888, several miners fired shots at his office and threatened to kill him. Hunter convinced the governor to send the Texas Rangers to end the violence. This image of a security detail for the mines dates to about 1900. The man at far right has a Colt single action Army revolver with a 4.75-inch barrel. (Courtesy of the Shupe Collection, WKGC.)

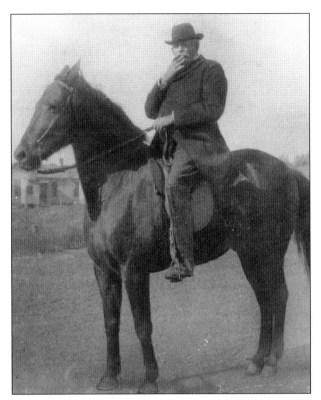

In 1894, a saloon just outside the perimeter of Thurber, known as Jimmy Grant's, became the object of attention when new owners decided to give away free beer. Miners drank so much that some were still intoxicated on their next shift, a condition that posed great danger, especially for those who handled dynamite. The company, understandably, issued an order that forbade men going to work while intoxicated. As R.D. Hunter feared, along with the saloon hurting profits from the company's saloons, emboldened union agitators without company security to stop them frequented the saloon. Hunter forbade miners from going to Grant's and requested local law enforcement to enforce his policy and close the road to the saloon. Hunter would not be controlled. (Courtesy of the Miles Hart Collection, Haley Library.)

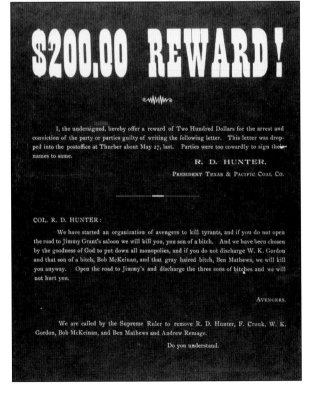

R.D. Hunter issued a $200 reward to arrest and convict the authors of a threatening note addressed to him that demanded the road to Jimmy Grant's saloon reopened or he would be killed. The note informed Hunter that a group of men would also kill him if he, W.K. Gordon, and several other officials were not removed from their positions. (Courtesy of Special Collection, University of Texas at Arlington.)

Between 1895 and 1900, about 870 to 900 miners extracted 30,000 tons of coal, but then the number of miners dropped to 725. W.K. Gordon advertised and sent recruiters to mining regions in St. Louis, Illinois, and Arkansas throughout 1900, offering to pay transportation to get them to the nonunionized mines. On one trip to Pittsburg, Kansas, A.B. Marston, assistant general manager of the Texas & Pacific Coal Company, and Edgar L. Marston's brother were engaged in a game of billiards when he collapsed in convulsions and died. The coroner ruled that he had been poisoned, suggesting that he was not welcome in the town as a recruiter or otherwise. This photograph shows Marston at the Hunter Club with an interesting group of men. Seated on the bottom step is A.H. Miller (left), who was Thurber's justice of the peace. Captain Collins (middle) was mayor of Stephenville. Seated in the rocking chair (third from right with dark waistcoat and bowler hat in hand) is A.B. Marston. The four men standing behind Marston were Rangers, including Sam Walt with his arms folded and his six-shooter in his holster belt. Frank Cronk (seated far right) was a hardware merchant. Also of note is Jessie, at far right in the doorway, who worked for R.D. Hunter, suggesting he was there even though not in the photograph. The other woman is an unnamed housekeeper. (Courtesy of the Miles Hart Collection, Haley Library.)

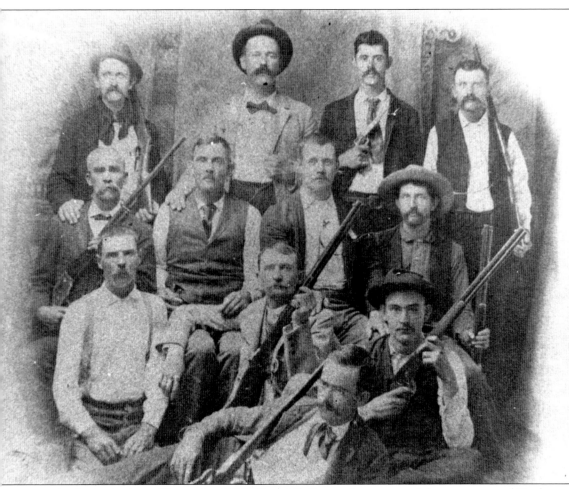

At the beginning of September 1903, Capt. J.B. Rogers, by request of the governor and Erath County sheriff Mack Creswell, went to Thurber to assess if additional men would be needed to control Thurber's striking miners. Rogers determined that his entire company was needed and that more companies from Dallas and Fort Worth could be needed to preserve order. It is unknown if Rogers was among the Rangers pictured here at Thurber. (Courtesy of the Cross Timbers Collection, Tarleton State University.)

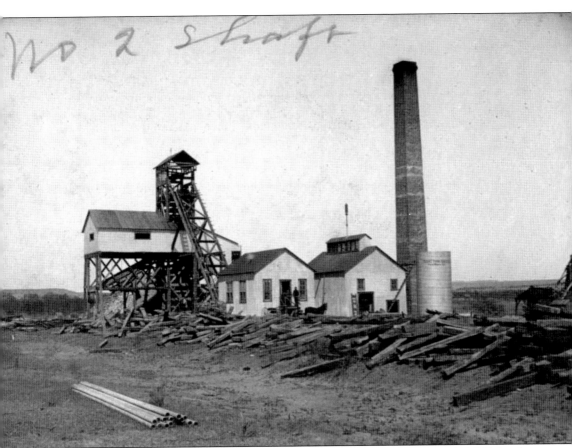

On September 10, 1903, a total of 287 miners from Lyra's United Mine Workers (UMW) local met 1,007 miners and workers from Thurber near the Rocky Creek Bridge in Palo Pinto County. By the end of the day, in the presence of W.M. Wardjon, the national organizer for the UMW, and Mr. Woodman, the secretary of the Texas Federation of Labor, hundreds of the miners had taken the union oath, including approximately 100 Mexican, 200 Italian, and 120 Poles. Within a week, the brick men, ice men, company clerks, and bartenders had organized. This marked the beginning of Thurber's unionization, as well as that of the Southwestern United States. The company, however, did not yet recognize this change. There is no image of the momentous occasion. This is Lyra's Mine No. 2, with many similarities to the mines in Thurber. (Courtesy of the Palo Pinto Historical Association via the Portal to Texas History.)

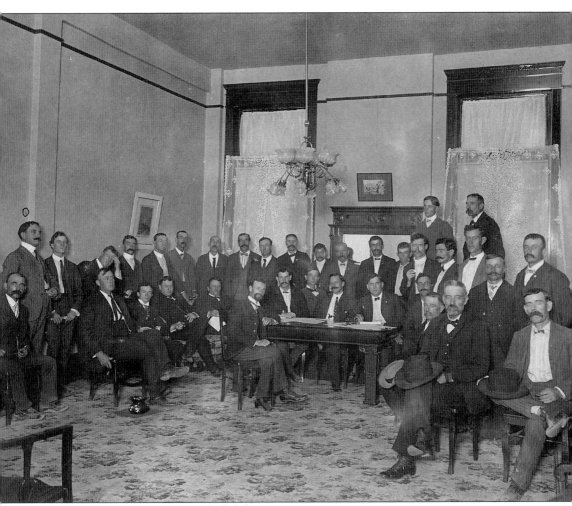

The Texas & Pacific Coal Company tried to resume operations in Mine No. 9 on September 16, but only six men reported to work. W.K. Gordon discovered that union leaders had arranged for the men to get work at other mines and that over 800 planned to leave within the week. W.K. Gordon (at left with mark over his head), Pres. Edgar L. Marston (seated at center of table), members of the Texas & Pacific Coal Company, and miners finally came to an agreement at a meeting with the help of C.W. Woodman, the secretary of the Texas Federation of Labor, and famous union negotiator John L. Lewis, future president of the United Mine Workers of America (seated at far end of table with bow tie, holding pen). As a result of this meeting, miners were paid bimonthly and worked eight-hour days. (Courtesy of the Lorenz Collection, WKGC.)

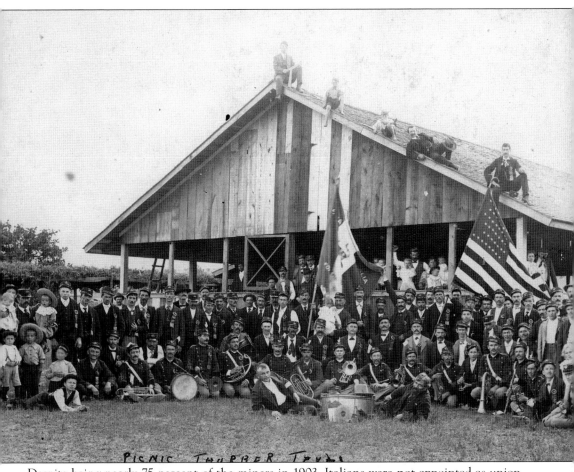

PICNIC THURBER TEXAS

Despite being nearly 75 percent of the miners in 1903, Italians were not appointed as union representatives. Within three years, their threats to become members of the Industrial Workers of the World were heeded, and the United Mine Workers approved the formation of Local No. 2753. This quickly became the stronger of the two chapters, as foreign and Black miners outnumbered the American miners. It is unknown if these miners belonged to the new chapter or, since they were wearing ribbons for the Societa Stella D'Italia, if it was taken before they were granted membership in Local No. 2753. (Courtesy of the Lorenz Collection, WKGC.)

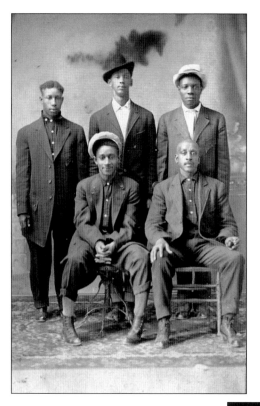

In 1906, the United Mine Workers held an international convention in Tomlinson Hall in Indianapolis, Indiana. Some 2,000 miners from around the country gathered to discuss mining interests, concerns, and conditions, including Black representatives from many of the unions. R.H. Smith, better known as Bob Rodgers (seated on right with his sons around him), represented Thurber's newest chapter of the United Mine Workers, No. 2763, which reportedly had 400 Italians and 100 Black members. It should be noted that Thurber's UMW was otherwise involved with mine workers in Texas. For example, in January 1904, it condemned Texas governor Samuel W.T. Lanham's use of convict laborers in Alba's mines. (Courtesy of the Minnick Collection, WKGC.)

Gomer Gower migrated from Wales and worked as both a weighmaster at Mine No. 2, a pit boss at New Mine No. 3, and then as a superintendent. Gower worked in mining centers across the Eastern, Midwestern, and Southwestern United States before he moved to Thurber. In 1889, R.D. Hunter initiated a system that did not pay miners for small pieces of coal that fell through a screen. The failure of the company to pay for the smaller coal reduced miners' pay by approximately 12 percent. Gower fought against the new system and for miners to receive fair wages for the coal they delivered. (Courtesy of the Miles Hart Collection, Haley Library.)

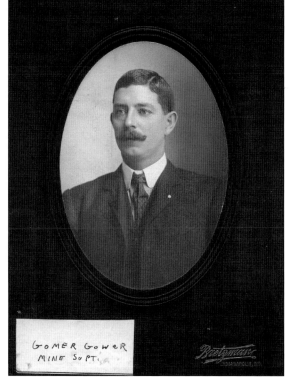

GOMER GOWER
MINE SUPT.

Thurber's charter for carpenters and joiners was created in September 1903 with the goals of initiating an eight-hour day and a livable wage, but it is unclear how long it lasted. Members could construct and work on the mine shafts as well as company houses. The Thurber Trades Council wrote to the United Brotherhood of Carpenters and Joiners of America to tell them that Local No. 729 had withdrawn. Upon their leaving, they were four months in arrears over per capita taxes, which were regular payments made to the national organization. (Courtesy of the WKGC.)

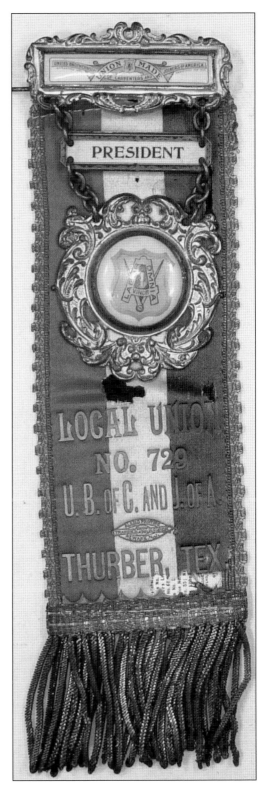

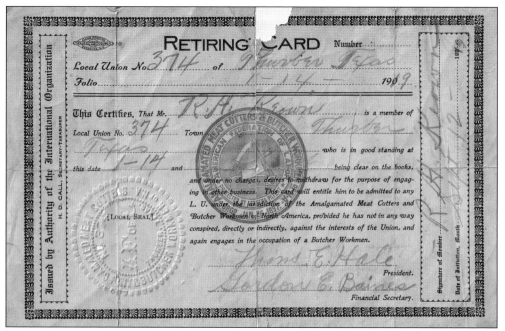

The Amalgamated Meat Cutters and Butcher Workmen of North America started Thurber's Local Union No. 374 in 1903. Men, including R.H. Keown, butchered and prepared all cuts of meat in the slaughterhouse and in the butcher shop. The meat was brought into town by various beef providers. (Courtesy of the Tate Collection, WKGC.)

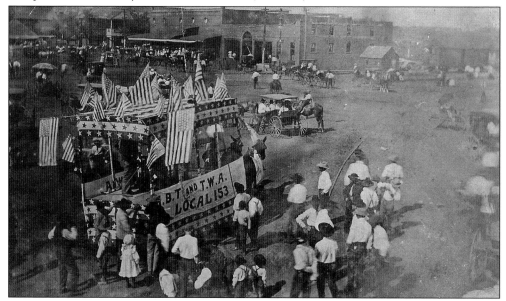

Thurber's Brick, Tile, and Terra Cotta Workers Association Local No. 153 had 169 members on October 14, 1903, making it possibly the largest chapter in the country. After unionization, they worked fewer hours for better pay and began stamping a triangle into each brick. This image shows people gathered around a Labor Day parade float. Among other union floats, Local 153 traveled the route with American flags and a banner. In the background, construction of the new general store is underway. (Courtesy of the Thomas Collection, WKGC.)

A strike in 1906 led Local No. 153 to renegotiate work to a "quantifiable measure of productivity," such as how many bricks or clay they processed; they also wanted 10-hour shifts and a wage increase of 10 percent. When this passed, the workers sometimes carried up to 100 bricks at a time to make the most money possible. The brickmakers then chose a new name, the Brick, Terra Cotta, and Tile Workers. The letters B T T were embossed in the corners of the union triangle on the bricks after 1906. (Courtesy of the WKGC.)

In 1908, Blanche Kessler, daughter of union member Xavier Kessler and the Labor Day celebration's maid of honor, addressed the crowd and extolled the merits of the union in Thurber. Praising the shorter hours miners worked, higher wages, and the increased quality of life, she opined that the day "should have been termed 'Union Labor Day,'" because without the Union we would have no Labor Day and no meaning attached to this particular day." (Courtesy of the Thomas Collection, WKGC.)

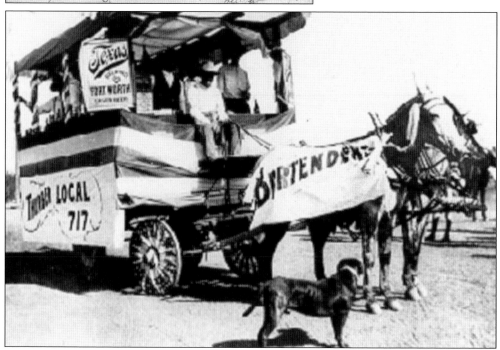

Sponsored parade carts lined the streets of Thurber during Labor Dar and Fourth of July celebrations. Pictured is a parade cart sponsored by the Thurber Local Bartender Union No. 717 and the Fort Worth Brewing Company. The bartenders and saloon owners of the Lizard and Snake Saloons in 1900 primarily came from foreign countries. (Courtesy of the Bennett Family Collection, WKGC.)

Five

A COMPANY TOWN

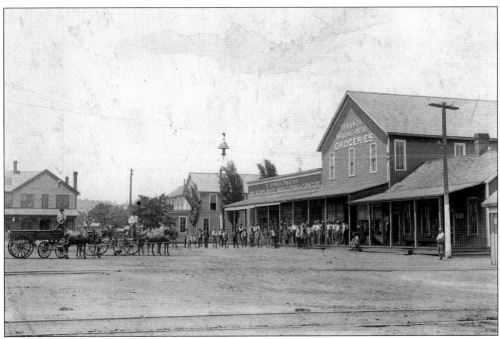

In 1888 and 1889, R.D. Hunter spent $56,494.94 to construct a town for the company. To prepare for the miners needed to extract large quantities of coal to meet demand from the Texas & Pacific Railroad and other customers, he arranged for 200 homes that had from two to five rooms, stores to purchase goods, a boardinghouse that was primarily for single men, stables for the mules and horses, churches and schools that addressed the ethnically diverse population, and company offices to keep the local records. By 1901, the downtown area was a bustling place. (Courtesy of the Lorenz Collection, Haley Library.)

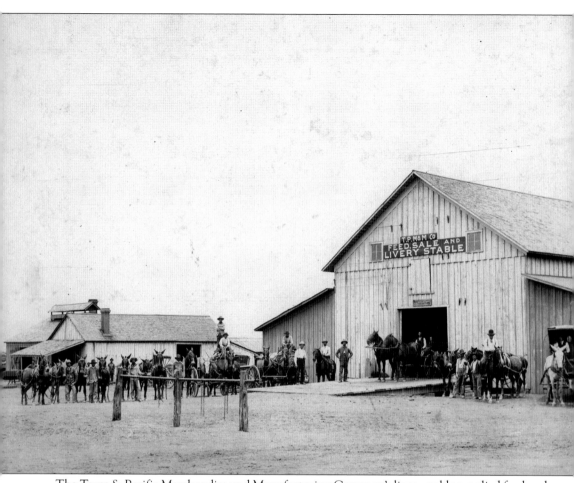

The Texas & Pacific Merchandise and Manufacturing Company's livery stable supplied feed and hay for purchase and served as a gathering place for many people in the town. Stables, a blacksmith shop, and a wagon repair shop occupied the same enormous building. Horses, buggies, and wagons were all available for hire, with increased business on Sundays. Its proximity to the T&P Railroad is evident by the train car visible at far left. (Courtesy of the Lorenz Collection, WKGC.)

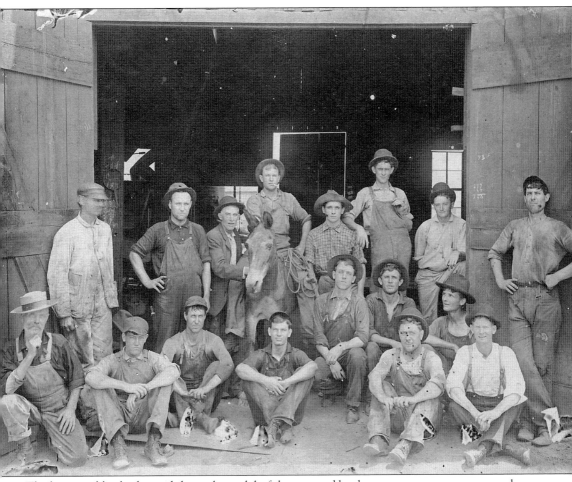

The livery stable also housed the mules and draft horses used by the company to transport people and equipment and bring coal to the surface before electric rail cars. This vital department was established in 1889, when Thurber's population increased to work the new mines and extract coal from below the ground. With the introduction of the automobile and the decreased need for mules in the mines, the livery department was closed. There are not many records of who worked with the animals and equipment other than Frank E. Whitworth Sr., who was listed as manager in 1918, with Dixie Fenner as assistant. (Courtesy of the Lorenz Collection, WKGC.)

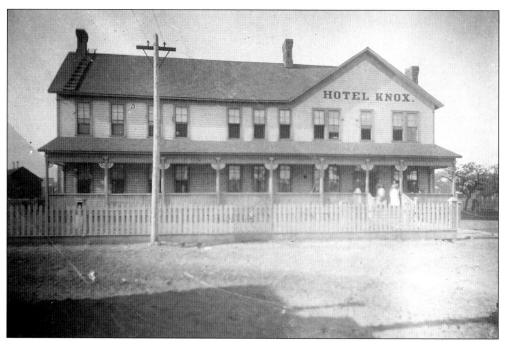

The Hotel Knox was built in 1894. In 1900, it was run by Yue Yie and Saue Yie from China. The Knox was the meeting place for many social events and hosted visitors and unmarried company executives who needed somewhere to stay in town. Guests benefitted from modern conveniences, such as electricity and running water supplied by the company's water plant. Rates varied from $2 to $2.50 per night or $18 per month. A remodel after a 1907 fire included a wing on the south side of the hotel. (Above, courtesy of the Cross Timbers Collection, WKGC; below, courtesy of the Lorenz Collection, WKGC.)

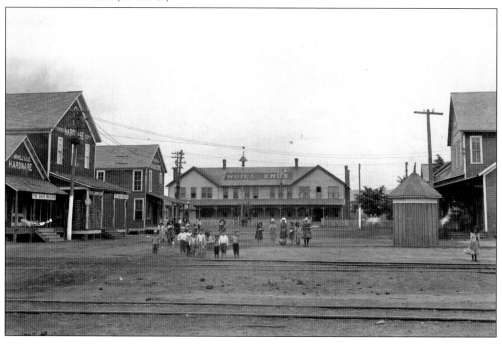

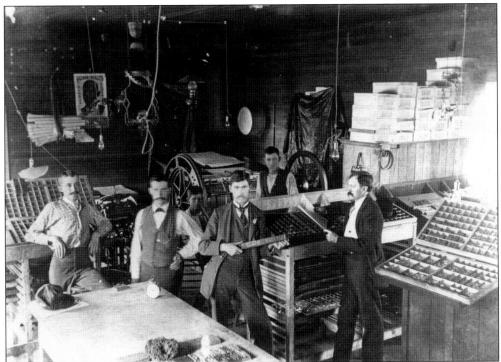

The print shop had all the machines necessary to produce a newspaper, several journals, and all other printed forms required by the company in the Thurber and Fort Worth offices. Two printers (one manual and the other automatic) were used in addition to two ultramodern Kelly presses. To help with assembly, there was also a power cutter. Catering to the large Italian population, the *Texas Miner*, 1894–1896, was printed in both Italian and English. The *Texas Mining and Trade Journal* started in 1897, and the *Thurber Tiny Journal* and the *Thurber General* were printed in the early 1900s. These newspapers had various advertisements for the company as well as a source of information for the people working and living in the area. When the main offices were moved to Fort Worth in 1934, the printing office was closed. (Both, courtesy of WKGC.)

POPULATION 5,000.

VOL. IV.—No. 29. THURBER, TEXAS: SATURDAY, FEBRUARY 3, 1900. WHOLE No. 185.

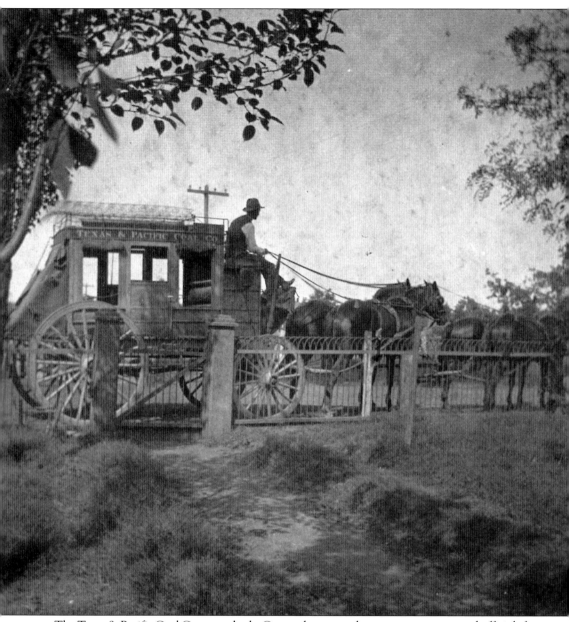

The Texas & Pacific Coal Company had a Concord stagecoach to transport guests and officials from Thurber Junction (present-day Mingus), where the main rail line ended. Driven by an experienced coachman with a team of four horses, the Thurber line was one of the last known stage stops in the United States. On the day this photograph was taken, the stage was either picking up or dropping off a passenger at Shadrick Mims's house. (Courtesy of the Mims Collection, WKGC.)

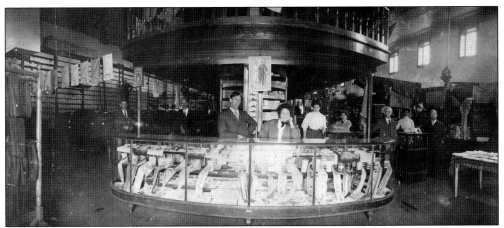

Above is the interior of the dry goods store, with men's clothing on the left, fabrics on the right, and ribbons at center. At left, a clerk stands on a ladder to reach goods on shelves at least 12 feet tall. An advertisement for President Suspenders is near a rack filled with men's trousers, as four men and four women stand ready to help the unseen customers in this undated photograph. Of course, there were also signs to encourage shoppers to purchase goods, such as a new hat. (Above, courtesy of the Lorenz Collection, WKGC; right, courtesy of the Thomas Collection, WKGC.)

DIED

September 15, 1925

Your Straw Hat

We sympathize with you in your loss and suggest that you try one of the New Fall Shapes in Lion Quality Felts that we have just received at $5.00.

Texas Pacific Mercantile & Mfg. Company
Thurber, Texas

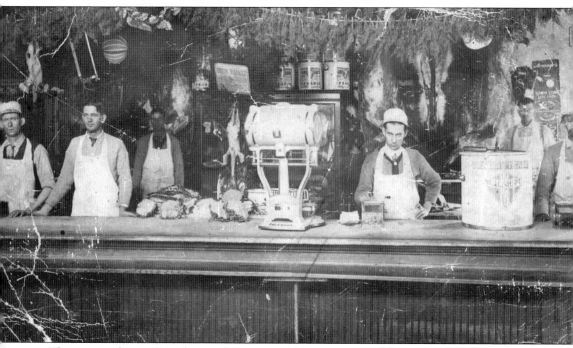

The meat market contained some of the most modern equipment of the time and a refrigerated area that was one of the state's largest. Fresh meat arrived regularly from the company's slaughterhouse and was butchered on site in as many cuts as it took to please the town's multiethnic population. Beef, pork, mutton, fowl, and fish raised on company land or purchased from other markets could be purchased. (Courtesy of the Tate Collection, WKGC.)

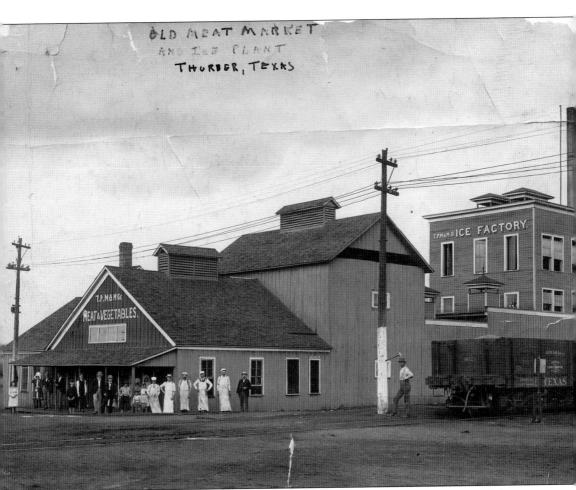

Using pecan wood in a nearby smokehouse, the butchers prepared salami, bologna, head cheese, and Polish sausage. Many residents, however, raised their own beef, pigs, and chickens and saved their company scrip for other household items. Behind the meat market, the ice factory made fresh meat and produce possible in homes and businesses. (Courtesy of the Miles Hart Collection, Haley Library.)

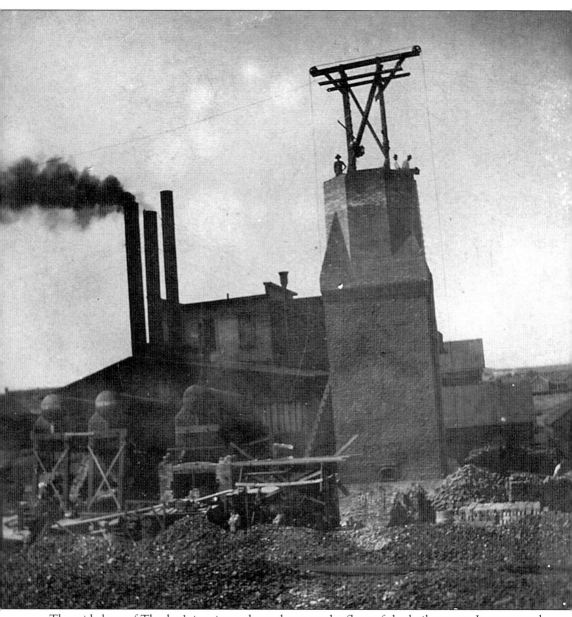

The wide base of Thurber's iconic smokestack sat on the floor of the boiler room. It connected to the once coal-heated boilers that generated the steam needed to power the dynamos. Its great height of 148 feet channeled the heavy smoke upwards to help decrease the amount of soot that could land on the town below. The switch from coal to gas omitted the soot-laden smoke, so the smokestack was no longer necessary. (Courtesy of the Thomas Collection, WKGC.)

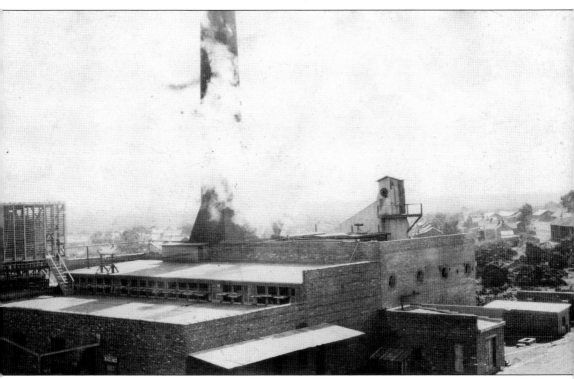

These buildings contained the ice and electric plants. Complete with a water filtration plant at left center, the 17-ton ice plant (the two-level roof on the left) had a loading dock at the front that was covered by an awning. The electric power plant (right) was attached to Thurber's landmark smokestack, which is seen here enveloped in a thick cloud of steam. The houses behind the massive structure have since been moved and replaced by Interstate 20. (Courtesy of the Studdard Collection, WKGC.)

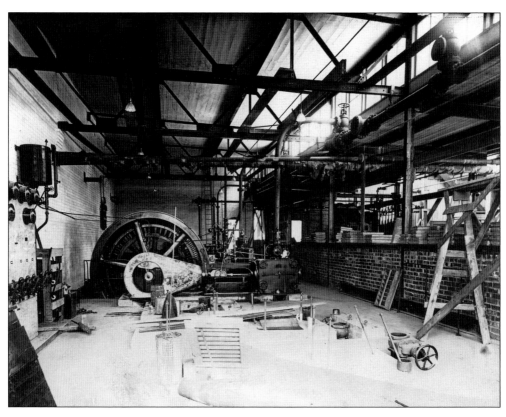

The electric power plant was built in 1895, enabling Thurber to be one of the first American towns to provide electricity to every house. Each "light drop," which consisted of a wire suspended from the ceiling of a room, cost the resident 25¢ per month. Massive steam engines powered the electric generators. (Both, courtesy of the Lorenz Collection, WKGC.)

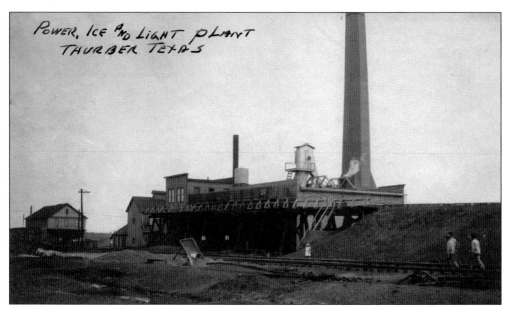

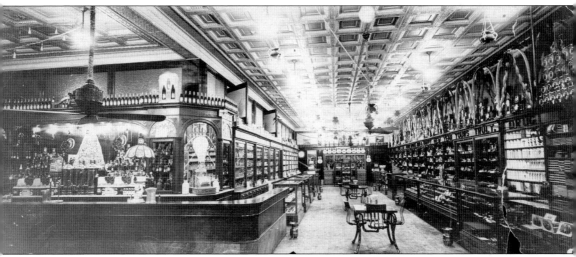

The drugstore sold novelties along with medicines. Customers could find writing supplies, including paper cutters, blotting pads, scissors, paper, crayons, and letter openers. Hair curlers, nail files, and tooth and nail brushes were also available. Kodak cameras, clocks, watches, and American Silver trusses (for hernias) were all available. (Courtesy of the Reynolds Collection, Haley Library.)

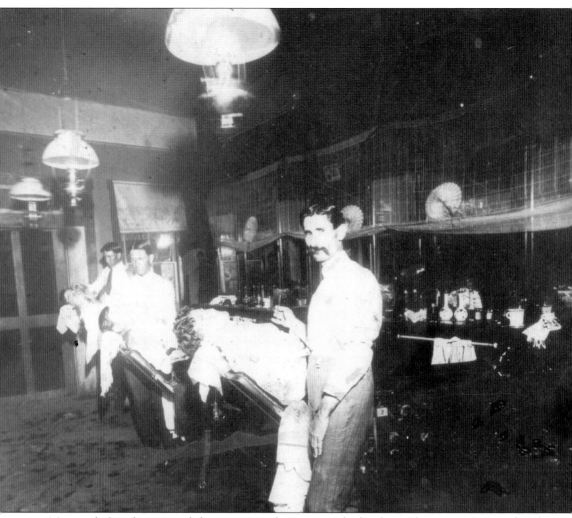

Men ready for a haircut and shave went to the company barbershop. Three men sit in reclined chairs as the barber in front prepares to use a straight-edge razor on the trusting customer under the glow from the electric lamps hanging above. (Courtesy of the Bennett Collection, WKGC.)

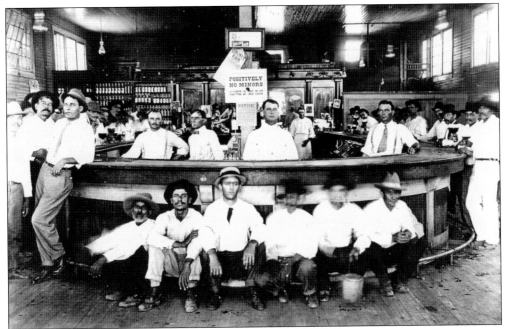

The Snake Saloon was a two-story building between the livery stable and the drugstore downtown. During the week, four bartenders worked the bar, but on the weekend eight to ten men were required to serve all of the workers. Women, gambling, dancing, and dance girls were not permitted in the saloon. A new Snake Saloon was constructed a quarter mile north of Thurber in Palo Pinto County in 1904 after the citizens of Erath County voted against the sale of alcohol. The sign behind the bar tells everyone that bartenders belonged to the union. (Above, courtesy of the Bennet Family Collection, WKGC; below, courtesy of the Thurber, Texas, Photograph Collection, Special Collections, the University of Texas at Arlington Libraries.)

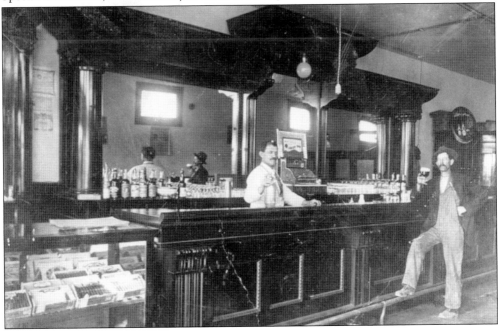

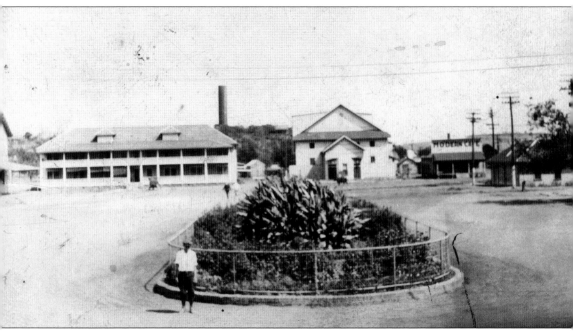

On the north side of the quadrangle downtown were (from left to right) the corner of the grocery store, Marston Hall, the opera house, the café, and the fire hall. Aside from being a boardinghouse, Marston Hall housed the county's only library, which was open in the evening and run by the Women's Missionary Council in 1913. (Courtesy of the Studdard Collection, WKGC.)

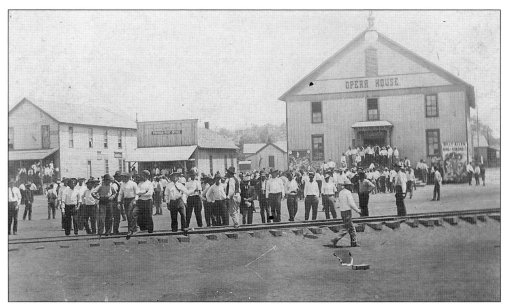

The opera house was built in 1896 and served as the center for most attractions in Thurber. It could seat over 600 guests, and the seats in the lower floor could be removed for dancing and other events. Grand balls, traveling shows, annual school plays, and boxing matches took place at the opera house during its first years. It was later turned into a movie house and showed the popular movies of the time. (Courtesy of the Thomas Collection, WKGC.)

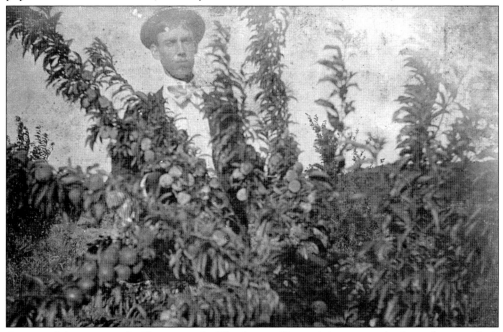

As part of the company's efforts to make Thurber a self-sustaining town, the farm also grew fruit and vegetables. According to the 1910 Census, 10 men worked the general farm. This was not the only source of fresh produce, as many residents had their own gardens and there were patches of grapes and even strawberries that were shared. Produce from the farm was sold in the company-owned stores, including this bumper crop of peaches. (Courtesy of the Bennett Collection, WKGC.)

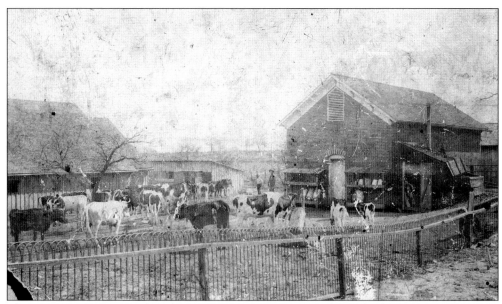

The Texas Pacific Mercantile and Manufacturing Company established a dairy in 1895 to provide residents with fresh milk. Relocated within a year due to a devastating fire, 35 Holstein cows were milked with modern equipment on a cement-floored facility. Dairymen prepared milk, cream, butter, buttermilk, and ice cream at a profit for nearly two decades. Residents purchased these products with scrip or regular money. (Courtesy of the Thurber, Texas, Photograph Collection, Special Collections, the University of Texas at Arlington Libraries.)

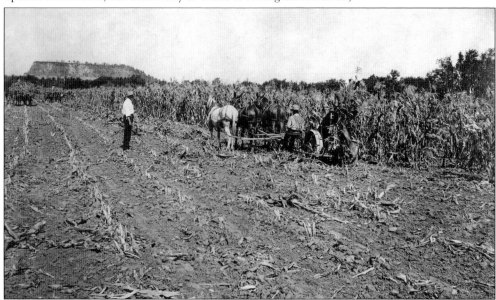

The company farm used the most modern equipment, including this harvesting machine designed to be pulled by two or three horses that cut and bound corn. Cutters generally had a knife that went back and forth over a stationary blade to sever the corn stalk from the ground. The weight of the wheel provided the power to cut through the toughest stalk. When cut, the stalks were carried up a chain to the deck and then bound together by a needle and knotter. The bundle of corn was then discarded from the machine. (Courtesy of the Miles Hart Collection, Haley Library.)

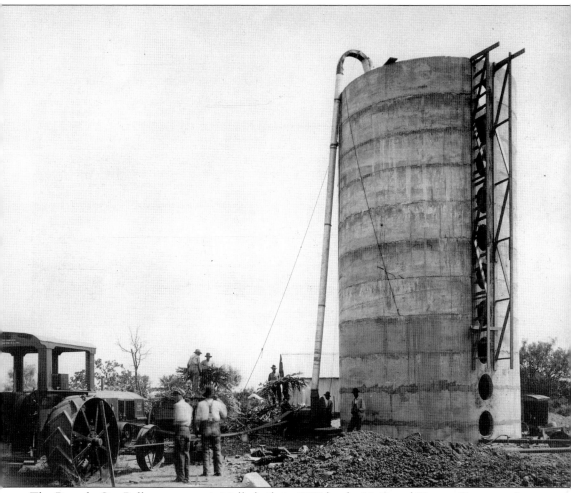

The Rumely Gas Pull tractor was initially built in 1909 by the Universal Tractor Company. It was manufactured by multiple companies, including the Minneapolis Threshing Machine Co, Union Iron Works, American-Abell, and the Universal Tractor Company, after the company sold the rights. It had a two-cylinder engine with a 7.5-inch bore and an 8-inch stroke, running at 600 revolutions per minute. With a two-speed transmission and a 3.5-inch diameter crankshaft, it was a heavy-duty machine. As farmworkers placed fresh corn silage into the auger lift, a belt attached to the side of the tractor generated the power that made it work. The silage traveled up the leg and into the silo for storage. The silos were not destroyed and still stand. (Courtesy of the Miles Hart Collection, Haley Library.)

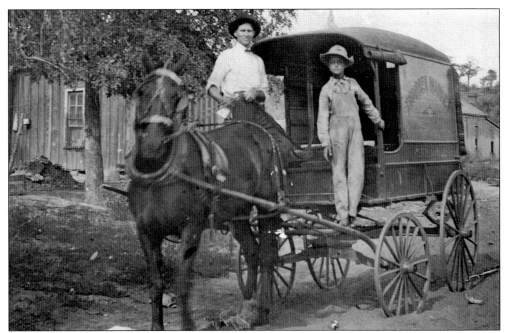

People in Thurber lived and worked together throughout the years. Allen Woodson, 30, was the manager at the ice plant in 1900. One of the boarders in his house, Will Ready, 26, drove the ice wagon. Parings such as John Woodlee and Sam Rollins, who both pulled ice at the plant, were not unusual. Will Stanton, driver of the wooden delivery wagon, worked at the meat market as the order clerk. His helper Gordon Baines was 11 years old. (Courtesy of the Carr Collection, WKGC.)

Firefighters were equipped with two trucks and a Harley-Davidson motorcycle. One came complete with chemical tanks, pumps, and 1,000 feet of hose; the other had a 30-gallon Badger chemical tank and 400 feet of 2.5-inch hose. With protective coats, hats, and boots for six men, C.C. Patterson, chief of Thurber's fire department, had the most modern equipment available to keep the town safe. The water filtration plant looms high above the fire station. (Courtesy of the WKGC.)

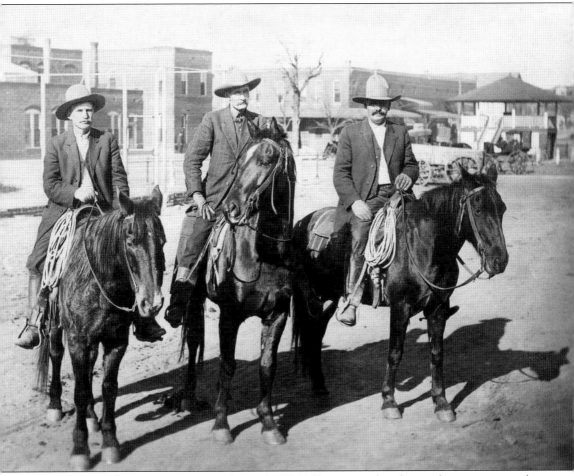

The "Three Bills," J.W. Ivey, J.W. Gailey, and W.T. Fulfer, are on their horses downtown around 1917. All ranched in the area and supplied Thurber's meat market with a steady supply of beef. Meat went from the company slaughterhouse north of town to the butcher shop. The ice plant provided the means to keep it cool and fresh. (Courtesy of the Hunt Collection, WKGC.)

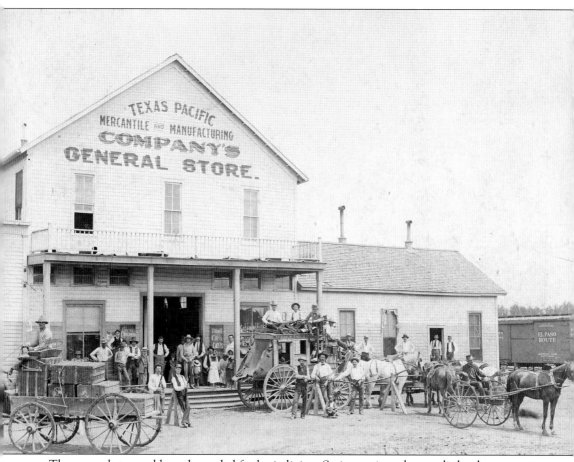

The general store sold goods needed for basic living. Scrip was issued as credit by the company to be used in any Texas & Pacific company-owned establishment as a form of payment. The old general store was destroyed by a fire on February 25, 1902, and was later rebuilt by the company. There was also a Texas & Pacific stagecoach to transport passengers. (Courtesy of the Cross Timbers Collection, Tarleton State University.)

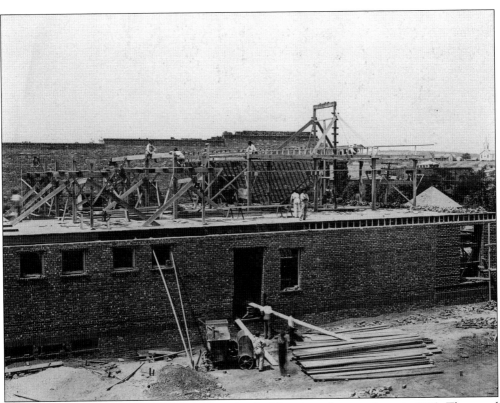

Construction of the new hardware and market building is underway above in 1913. The wood frame interior is barely visible due to the progress of the brick layers. The side view above and front view below show a practical building for use, not ornament, although it does contain some basic architectural elements. Stones on the unpaved road served as steps when the roads were muddy. (Above, courtesy of the Lorenz Collection, WKGC; below, courtesy of the Studdard Collection, WKGC.)

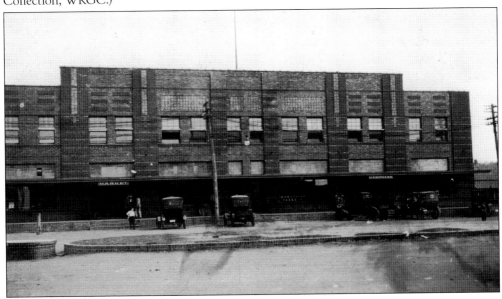

There were many important jobs in Thurber, including the company machinist and mechanics. With the crucial job of repairing vital equipment, including lifesaving machinery in the mines, brick forming equipment in the factory, machines in the offices and businesses, and countless moving parts in vehicles, these men were depended on by the company to keep it generating profits. For many repairs, parts were not easily replaced because they could rarely be ordered. This meant the job fell on the machinist to create an entirely new part from scratch. (Courtesy of the Thomas Collection, WKGC.)

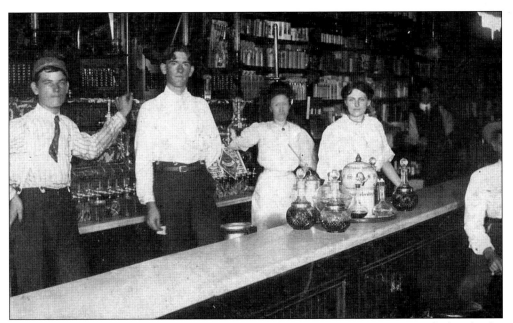

Records and photographs of women working in Thurber are scant. Lena Bowers worked in the dry goods store as a cashier with Lottie Davenport. Daisey Varley and Laurelyn Woodall worked in the grocery store. Louise Pinkston was a saleslady, Alice Hall and Victoria Tackett were laundresses, and Veta Perry was a nurse at the hospital. The two women working in this photograph remain unidentified. (Courtesy of the Thomas Collection, WKGC.)

A 1919 Ford Rumbleseat Roadster and a 1919 Deluxe touring car are parked in front of the dry goods and furniture store (left) and grocery store (right). With bricked sidewalks and defined streets, there was also a green space down the middle of the quadrangle in 1921. Mr. Lunardon stands on the center crossing seemingly looking up at the photographer. Easily overlooked are the sprinklers that are discharging water on the grass and shrubbery. (Courtesy of the Studdard Collection, WKGC.)

This image of downtown Thurber in 1921 shows some of the busiest stores in town. The side of the hardware store is visible at far left, with the new post office located in the downstairs of the next building and doctors' offices upstairs. Next is the barbershop building, which also had a doctor's office and the telephone office on the upstairs floor. On the right is the drugstore. Among the beautiful vintage cars parked straight in rather than parallel to the sidewalk is a wagon. (Courtesy of the Studdard Collection, WKGC.)

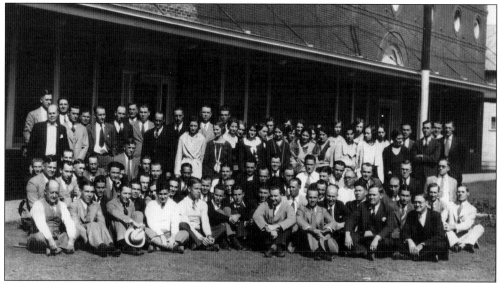

Some women took advantage of limited opportunities to work outside of their homes. Office personnel from 1931 included the Calloway sisters Ruth (bookkeeper), Evelyn (executive secretary), and Helen and Mary (stenographers); Jo Kimbro (bookkeeper); Zeta Taylor Turner (stenographer); and the Creighton sisters Hazel (bookkeeper), and Velma and Kathleen (stenographers). Other company stenographers were Thelma Schmerber, Margaret Gilmore, Eva Marshall, Roxie Coody, Caroline Heathrington, and Edith McCulloch. Lillie Gerhard, Sally Pales, Margaret Lane, Janie B. Rudler, Zelda Woods, and Thelma Thomas were also part of the clerical personnel, but their positions are unknown. (Courtesy of the Studdard Collection, WKGC.)

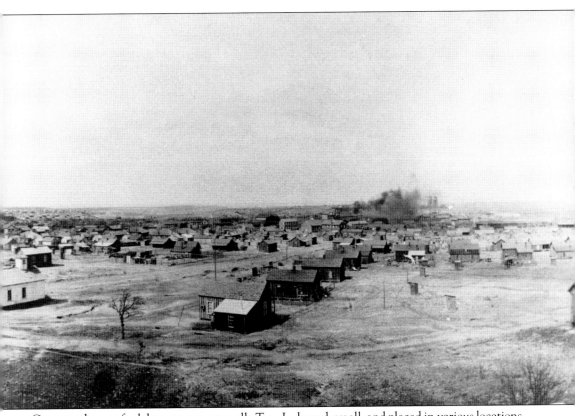

Company houses for laborers were generally T- or L-shaped, small, and placed in various locations. Most had two to three rooms with small yards, with a common outhouse outside. The company charged more in rent for picket fences, so only a few homes had them. This photograph faces north, showing a view of the shared outhouses in a field in the foreground and the company water towers to the right of an enormous cloud of dust. Lack of modern sewage contributed to sickness and death. Cholera caused the deaths of 18 children ranging in age from one month to a year-and-a-half from 1903 to 1909. Malaria also added to the death toll during those years. (Courtesy of the Thurber, Texas, Photograph Collection, Special Collections, the University of Texas at Arlington Libraries.)

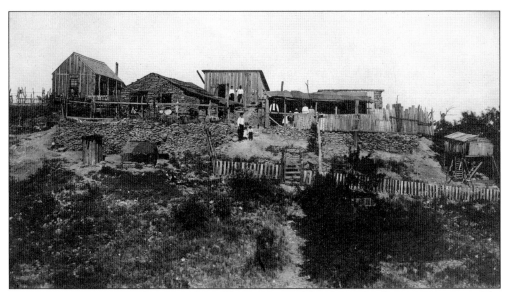

Everyone may have worked and conducted business in public places, but housing areas, just like the graveyard, were segregated. There were Italian Hill and Polander Hill, located on No. 3 hill due to its proximity to Mine No. 3. New York Hill on the southern end of Thurber was home to management primarily involved with the Ranger oil field. Graveyard Hill overlooked the town from the north, so named for the graveyard where hundreds of residents were buried in the Protestant, Catholic, or African American sections. Stump Hill was southeast of No. 3 and northwest of New York Hill. Named after the stumps that were cleared before the houses were built, it was home to Thurber's Mexican population. (Courtesy of the Thurber, Texas, Photograph Collection, Special Collections, the University of Texas at Arlington Libraries.)

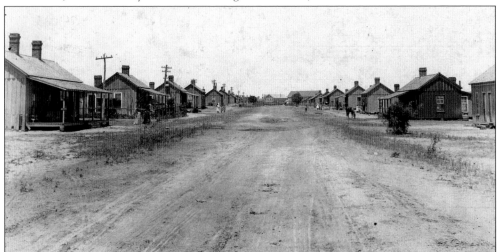

Here is a typical street scene in one of the neighborhoods. One house has a horse grazing on what looks like a very small supply of fresh grass. The house directly across the street has a fenced-in yard and healthy vegetation. Some Thurber residents grew their own vegetables to supplement their diets and save money. It appears the woman standing on her porch may have been having a conversation with the other two women standing at her fence, as children play outside a little farther down. This street, like all others in Thurber, was not paved. (Courtesy of the Lorenz Collection, WKGC.)

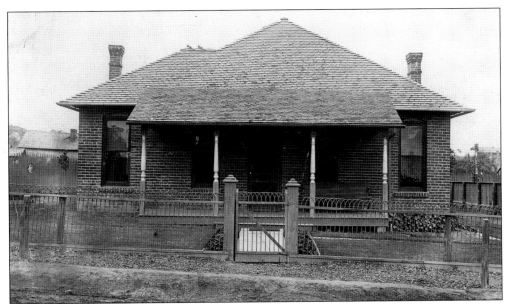

In 1900, the brick company became part of the Texas & Pacific Coal Company with the acquisition of all but 180 of 2,000 shares for $91,233.21. Now it was not necessary to import bricks from St. Louis. Seven out of twenty houses on Marston Street, referred to as "Silk Stocking Road," were considerably different from houses in town. Located on New York Hill, where upper management generally resided, they had brick exteriors, cedar shake shingles on the roofs, and chimneys for inside fireplaces. (Courtesy of the Thomas Collection, WKGC.)

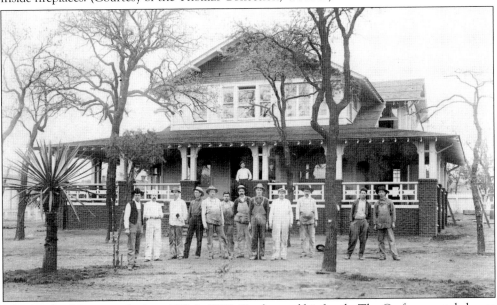

The Gordon House was built in 1912 for W.K. Gordon and his family. The Craftsman-style house was the only one of its kind in Thurber, with radiators for heat, a basement, two stories, and a large porch. The ground-level floor had six rooms—living, dining, breakfast, two bedrooms, and a kitchen—plus two bathrooms and a screened-in porch. There were three more bedrooms and two bathrooms on the second floor. While the miners had privies outside, the opulence of indoor plumbing was surely the source of much envy. (Courtesy of the WKGC.)

RANGERS HOT ON THE TRAIL

CAPT. McDONALD AND HIS COMPANY AT THE FRONT.

The Gordon Train Robbers Were Seen at a Number of Places—The Sheriffs of Two Counties After the Thieves—The Safe Brought Here.

Gordon, Tex., Oct. 20.—The four men who robbed the Pacific express car on the Texas and Pacific three miles east of this place yesterday, were well dressed, wore gold rings, chains and watches. Three were medium in height. One was small and wore very small high-heeled boots. One of the taller was of florid complexion and had stubby, sandy mustache and all were armed with needle guns. They went south, to where they had their horses hidden in a pasture; thence north across the Texas and Pacific railway, by the house of Riley Silcox, where one waved his hat to Mr. Reynolds; on through Coalville, and past the house of Mrs. A. P. Carson and the Ringor place. They rode fine horses, one black and three bays, shod. The black and one bay are pacers. One bay travels in a rapid fox-trot. The robbers informed the section men that they were after the Thurber money. This they failed to get.

While not part of the town, some excitement occurred on October 19, 1894, when four men robbed a Texas & Pacific railcar to get Thurber's $10,000 payroll en route from Fort Worth. In typical wild West style, they rode horses—one black, three bays—wore fancy clothes with gold jewelry and watches on chains and were all armed with needle guns. Within hours, a mounted posse set out to hunt for the men presumed to be hiding in the Palo Pinto mountains. The safe, which the robbers failed to get, was delivered to Fort Worth for repairs to its combination system. (Courtesy of the *Dallas Morning News*.)

Throughout the years, new inventions that made working conditions faster and safer were patented by Thurber employees. William Lewis received a patent on April 18, 1893, for a steam pressure and water level recorder for boilers, which allowed for proper monitoring of pressure and water levels in fire-heated boilers kept at boiling point. This freed operators from constantly monitoring the fire to maintain a steady supply of steam. (Courtesy of the Portal to Texas History.)

W.K. Gordon went to work for the Texas & Pacific Coal Company as an engineer shortly after he surveyed a proposed route for the railroad from Thurber to Dublin in 1889. Among his skills as an engineer was designing new equipment for mining. His first patent was for a saw-operating mechanism in April 1897 that allowed miners to crosscut wood on the ground. Seven months later, he patented an automatic dumping cage, which tilted to dump the coal when the carriage almost reached the top of the hoist and returned it on the way down. (Courtesy of the Portal to Texas History.)

In 1902, two men from Thurber, Levi D. Gibson and Robert Loflin, a hardware salesman, joined with Herman F. Scheer, a coal mine drummer, from Dallas to patent a mechanical movement that improved rotary movements. The inventors stressed that this would be useful for multiple applications but that their intention was for it to be used in a churn or washing machine. (Courtesy of the Portal to Texas History.)

Leonard F. Williams filed his application for a patent on May 31, 1904, for a recharging valve for auxiliary reservoirs in the air brake systems of automobiles that did not require brakes to be released. Williams also received a patent for an air brake governor on July 10, 1906. The air brake governor was an automatic device for fluid-pressure brakes and for air-pressure brakes on railway cars and trains. By regulating the amount of pressure applied to the brakes, it stopped wheels from locking up and flattening as they slid on railway tracks. (Both, courtesy of the Portal to Texas History.)

Frank Bida, an immigrant from Austria-Hungary, invented an automatic switch-throwing apparatus for the railroads that received a patent on December 5, 1916. The controller for this switch would be in the hands of an operator riding on a train who could open, close, and lock the tracks as needed while in motion. (Courtesy of the Portal to Texas History.)

Athelstan O. Jones filed a patent on November 3, 1898, and received one on February 6, 1900, for a lift for heavy material into railcars or onto any other surface. His invention depended on material, such as bricks, being stacked a certain height to fit inside the top of the C-shaped structure. Made with framed bars that would slide between the bars of a stacking platform, it would then fit neatly around the material and lift it where needed. (Courtesy of the Portal to Texas History.)

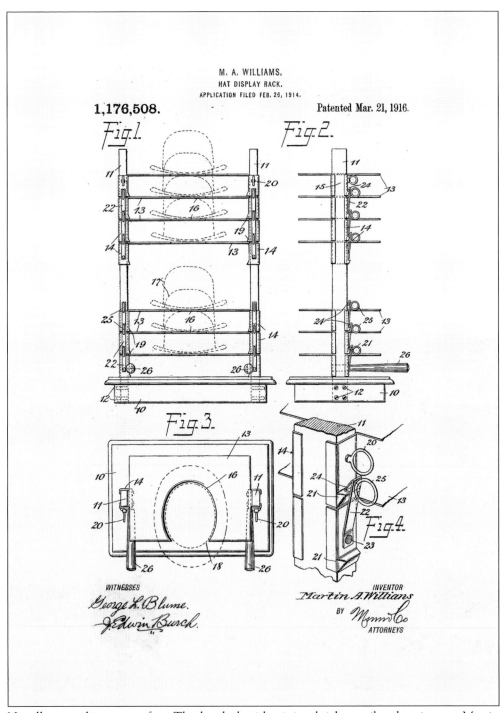

M. A. WILLIAMS.
HAT DISPLAY RACK.
APPLICATION FILED FEB. 26, 1914.

1,176,508.

Patented Mar. 21, 1916.

Fig.1.

Fig.2.

Fig.3.

Fig.4.

WITNESSES
George L. Blume.
J. Edwin Busch.

INVENTOR
Martin A. Williams
BY Munn & Co
ATTORNEYS

Not all patented inventions from Thurber dealt with mining, brick, or railroad equipment. Martin A. Williams's hat display rack solved the problem for haberdasheries of how to display a full line of hats in a restricted space. Each shelf could be adjusted as needed for easy removal and to adjust for the varying size of different hats. It took a little over two years, but Williams received his patent on March 21, 1916. (Courtesy of the Portal to Texas History.)

Six

SOCIETY

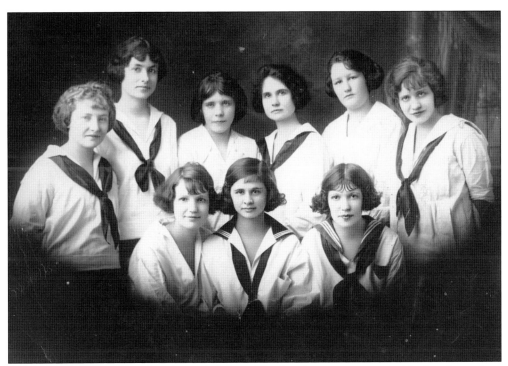

Young women often formed and joined clubs in Thurber that were supervised by female teachers from the local schools. Helen Marrs participated in the Gypsy, SNAKE, and FUN Clubs. It is unknown what the names stood for. Each offered social interactions for young women in the company town. These members of the SNAKE Club are, from left to right, (first row) Alta Latimer, Lucille Southern, and Marie Keown; (second row) Juanita White, Miss Pinson, Artie McCun, Miss Powers, Lena Mae, and Helen Marrs. (Courtesy of the Tate Collection, WKGC.)

Auela John	Head	w	m	June	1864	36	m	6
— Amelia	wife	w	f	Oct	1866	34	m	6
— Victoria	Daughter	w	f	Feb	1896	4	P	
— Anna	Daughter	w	f	Aug	1898	2	P	
Saleramo Joe	Boarder	w	m	Apr	1860	40	P	
Rafaele Frank	Boarder	w	m	Jan	1865	35	m	un
Calvette Silvio	Boarder	w	m	Apr	1869	31	P	
Merle Eurilio	Boarder	w	m	June	1870	30	m	un
Orlbello Eurilio	Boarder	w	m	Sept	1865	34	P	
Tobio Alonsio	Boarder	w	m	June	1881	18	P	

As in all company towns, women were seldom, if ever, recognized for their work. An example is Rosana Richardson, 48, married to Charles, 36. Along with caring for her children, who ranged from 9 to 20 years old, she also had six boarders, ranging from 22 to 70 years old, in the house. Her husband, two of her sons, and all six of the boarders were coal miners. The 1900 Census taker left her occupation, and most of the women's, as an empty space, but she would have been responsible for all of the tasks to prepare the men for a day at work, as well as taking care of her home, husband, and children. (Courtesy of the National Archives.)

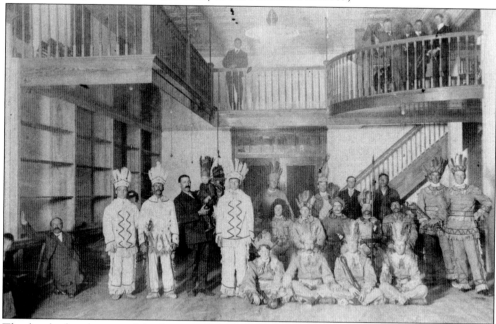

Thurber had a chapter of the Improved Order of Red Men, which held meetings behind the hardware store. It was established soon after Capt. William Lightfoot, Chief John Eyley, Lieutenant Williams, Abe Masters, Thomas Guthrie, Victor Anderson, and Frank Yell from Thurber attended a meeting of Red Men in the neighboring mining town of Strawn. The Improved Order of Red Men was founded in 1765 to promote freedom and liberty in the colonies. They modeled themselves after the Iroquois Confederacy and its democratic governing body with devotion to the United States and the principles of liberty. (Courtesy of the Bennett Collection, WKGC.)

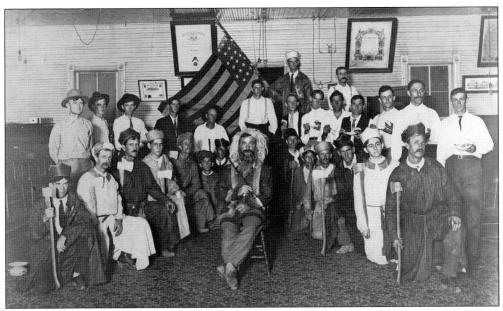

The Woodmen of the Word (WOW) also had a chapter at Thurber. Shown here with their axes with aluminum heads, the men appear to be holding a ceremony. The fraternity provided insurance for its members, as it promoted benevolence within the community. Perhaps one of the most recognizable symbols of WOW is its unique tombstones on members' graves. Thurber Cemetery has many. (Courtesy of the Thomas Collection, WKGC.)

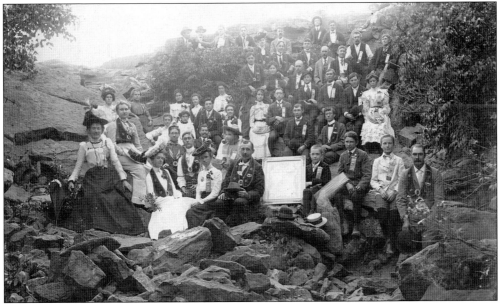

Members of Thurber's International Organization of Good Templars (IOGT) pose on an outing. Exactly how many problems alcohol caused is unknown, but the Erath County jail logs suggest that drunkenness and crimes possibly related to alcohol were issues in the county. As a participant in the temperance movement, the IOGT stressed abstinence from alcohol. Judging from the number of members in this photograph, it was a popular fraternal organization. (Courtesy of the Thurber, Texas, Photograph Collection, Special Collections, the University of Texas at Arlington Libraries.)

Jack Thomas (left) touches gloves with his opponent. Thomas was a boxer who moved back and forth from Thurber and Girard, Kansas, another mining community, during the 1910s. His brother Oliver (far left) became the father of one of Thurber's World War II veterans, Kessler Thomas. Bobby Waugh (second from right) was one of the most famous boxers in the mine circuits. Waugh headlined multiple fights throughout Texas and New Mexico. Boxing matches in Thurber took place at the famous opera house. (Courtesy of the Thomas Collection, WKGC.)

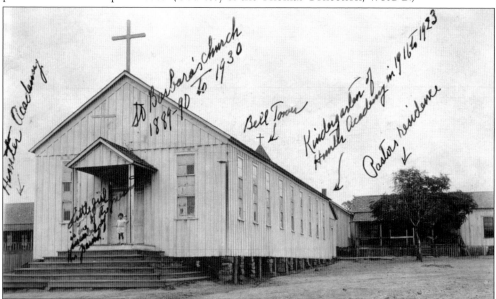

Built in 1892, St. Barbara's Catholic Church hosted most of the weddings in Thurber. Many priests served the community, including Fathers Dynia, Kwoka, Etschenberg, Dolje, Baker, Morendino, Fabrio, Ardus, Kowalski, Gagliardoni, Dow, and DeLuca. The company provided resources for the church and maintained the buildings. Hunter Morning Star Church and Sunday school were held on the fourth Sunday of every month, where A.R. Ditto was the pastor. The American Methodist Church held services on the second Sunday in the morning and evening, with a class meeting at 3:00 p.m. J.H. Smith was the pastor. (Courtesy of Dallas Diocese Archive Collection.)

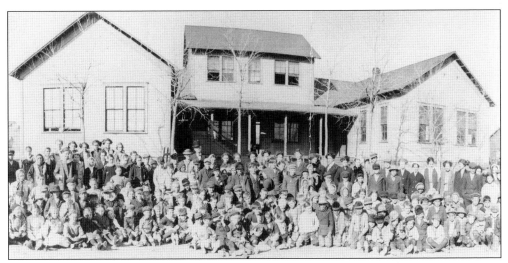

The large Catholic population in Thurber led to the creation of Hunter Academy in 1894. Hunter Academy was a Catholic school operated by the Sisters of Incarnate Word from San Antonio, Texas, and was one of three of Thurber's schools, including the public school and the African American school. Hunter Academy closed its doors in 1923, twelve years before the public school closed. (Courtesy of the Gibson Collection, WKGC.)

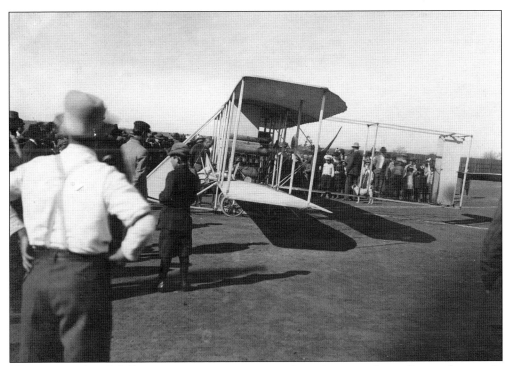

The company hired different acts to come to town, such as circuses and traveling performers. In 1908, something completely out of the blue came to Thurber when a biplane landed on company property. Throngs of people gathered to marvel at the contraption and the possibilities of air travel just five years after the Wright brothers had made their famous flight. (Courtesy of the Southwest Collection, Texas Tech University.)

The 1922 T.P. School tennis club poses for a team photograph. The tennis club was one of the few coed clubs at the Thurber public school. From left to right are (first row) Lena May Judon, Robert Chisolm, Virgil Roberts, and Audrey Stevens; (second row) Edgar Singleton, L.E. Forrest, Jas Judon, Lewis Taylor, and T.A. Parker. (Courtesy of the Bennet Family Collection, WKGC.)

Football was one of the sports offered at the Thurber public school. Shown here is the 1925 team, including Coach Bates. The team played its games at Thurber's Park Row Ball Park. Other sports included baseball, basketball, track, and tennis. Boys and girls participated in basketball, tennis, and track; however, only boys were allowed to play football and baseball. Girls exclusively joined the hiking, golf, archery, and croquet clubs. (Courtesy of the Bennet Family Collection, WKGC.)

Many families, such as members of the Thomas and Kessler families in this photograph, took advantage of the recreational facilities at Big Lake, a 150-acre site constructed at the cost of $21,138.45 as a water reservoir for the town after it was determined that Little Lake was not big enough. Fishing and boating were allowed at both Big and Little Lakes; however, Big Lake was reserved for members of the Thurber Club, originally named the R.D. Hunter Fishing and Boating Club. (Courtesy of the Thomas Collection, WKGC.)

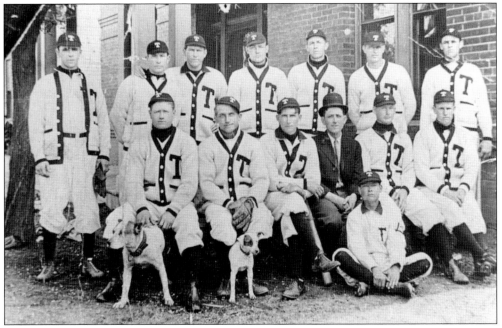

The Thurber Miners pose for a team picture before a game against the North Side Athletics at Haines Park. The Miners were considered one of the best minor league teams in the southwest. They played their home games at Park Row Ball Park, a multisport facility that the company built for the town in 1907. (Courtesy of the Thomas Collection, WKGC.)

Water from Big Lake traveled through a mile-long pipe to Cemetery Hill, where it was stored in two water tanks. From there, water was delivered in a tank wagon to residents willing to pay up to 25¢ per barrel. These young men had a prime view from the platforms of the tanks, which are still on the side of the hill. (Courtesy of the Southwest Collection, Texas Tech University.)

The International Association of Rebekah Assemblies was the White women's auxiliary of the Independent Order of Odd Fellows. Thurber's African American women had two organizations, including the House of Ruth No. 163, which met on Wednesday nights, and the Queen Esther Chapter No. 11, Order of Eastern Start, the women's auxiliary for Prince Hall Freemasons, which met on Thursday nights. There are no images of African American women's meetings. This image of the Rebekahs is from an outing, possibly to Palo Pinto County. (Courtesy of the Thurber, Texas, Photograph Collection, Special Collections, the University of Texas at Arlington Libraries.)

Deaconess Mary Wood, with the Woman's Missionary Council of the Methodist Episcopalian Mission that was housed in Marston Hall, ran a sewing school for the Italian girls, a Sunday school, and a class for the Mexican children to learn English. Over the course of 1913, she made 385 visits in town, conducted weekly prayer meetings, and hosted a temperance club for the youth of the town. Wood and the women who worked with her offered many services to the young and old residents of Thurber, including running the only library in Erath County. (Both, courtesy of the Dovalina Collection, WKGC.)

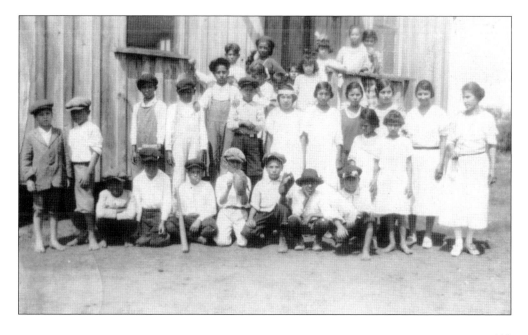

Eight boys of the Thurber Tigers Little League baseball team ages 8 to 10 pose for a team photograph with gloves, baseballs, and bats around 1908–1910. From left to right are (first row) Nat Wilson, Jack ?, and Hunter Lightfoot; (second row) Jim Gower (son of Gomer Gower from Wales, who worked as a weighmaster at the Thurber mines), Chase Wilson, Louis Finley, Joe Porzetti, and unidentified. (Courtesy of the Cooney Collection, WKGC.)

The Thurber brass band was a school band and one of the many bands in Thurber. Some of the members include (first row) Willow Harmon, Rex Roberts, Ted Bott, and Bobby Beverage; (second row) band director Wallace Barlow, Elton Willett, Bruce Hewely, Ray Gerherd, and T.A. Parker. The brass band and other bands would perform shows at the bandstand downtown. (Courtesy of the Bennet Family Collection, WKGC.)

The Thurber Cemetery offers a trip back in time to the diverse population that once lived together. Croatian was one of the 18 known ethnic groups in Thurber. This Croatian family erected an elaborate headstone for their children. Its engraving translates to "Here are resting in peace two sisters, Olga and Marija. Let the soil be light for them." (Courtesy of the Lorenz Collection, WKGC.)

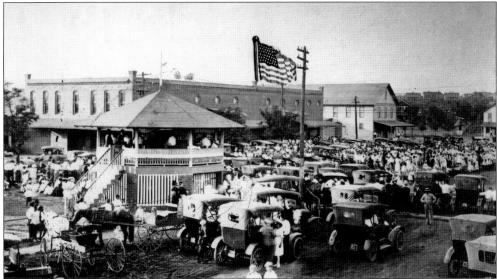

A large gathering held downtown celebrated Armistice Day, November 11, 1918. People on the left sit on the grass and look toward the speaker at far right, who addresses a crowd who all had chairs, indicating a planned event. Women in dresses and bonnets and men in white shirts and hats all watch. A band waits its turn in the bandstand, while cars and carriages surround the crowd. With many of Thurber's young men away fighting in the war, Thurberites were as anxious as the rest of the world for peace to be announced. A 48-star American flag was drawn on the photograph at some point. (Courtesy of the Terrell Collection, WKGC.)

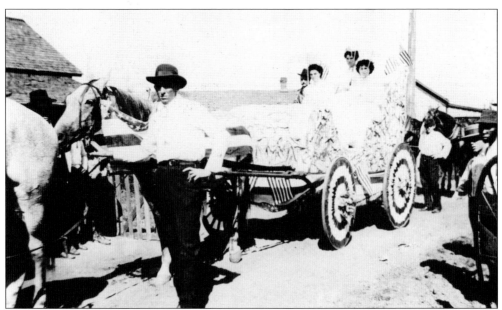

Labor Day and Independence Day were major holidays in Thurber. Parades and festivities lasted all day and well into the night, when a town dance took over the festivities. This parade from 1908 contains a clear image of the water towers on Cemetery Hill (top left) behind the opera house on the main square. The well-dressed crowd watches as the buggies filter by. (Courtesy of the Bennet Family Collection, WKGC.)

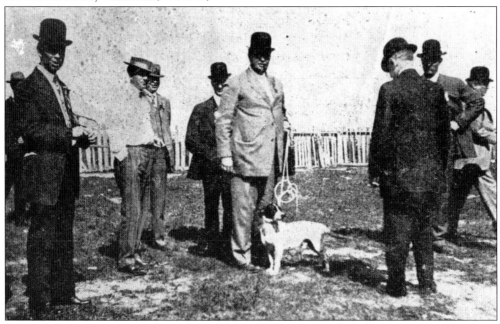

Badger fighting was a popular "sport" in Thurber. Edgar Marston brought friends from New York to watch the fight. A prank that people in Thurber knew about included betting on the fight and encouraging the unsuspecting guest to release the badger. When he finally mustered the courage to release the badger, the guest saw a bedpan or other object and understood he was the victim of a prank. (Courtesy of WKGC.)

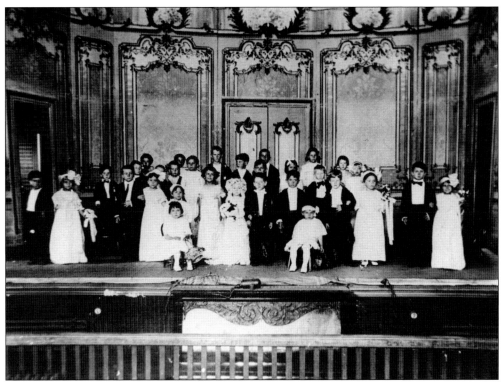

Young children, such as this well-dressed group from about 1910, often performed plays at the Thurber Opera House. The junior and senior high school play was a yearly event that students looked forward to hosting for the town. Plays, traveling shows, badger fights, and other social events were routinely held at the opera house. (Courtesy of the Bennet Family Collection, WKGC.)

New Year's Eve dances at the Thurber Club required a proper dance card. The 17th annual dance at the Thurber Club Rooms on December 31, 1925, included multiple fox trots and waltzes. Interestingly, dances for the Thurber Athletic Club in 1921 did not include such intricate dances. The dance card for that event listed one-steps, waltzes, and a moonlight. (Courtesy of the McCorkle Collection, WKGC.)

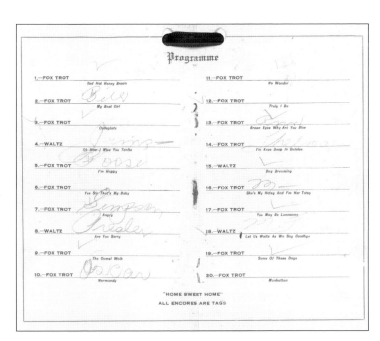

Women played a significant role in the many schools and after-school clubs in Thurber. Many teachers, such as Robbie Powers in 1922, taught multiple subjects, including English and Spanish. Powers and Miss Pinson were also members or honorary members in many of their students' social clubs. Miss Braham also coached the 1922 women's basketball team. (Courtesy of the WKGC.)

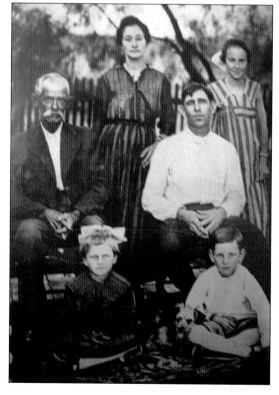

Herbert Bayer started working in the brickyard when he was 12 years old. When World War I began, he, like other Thurber residents, signed up for the armed forces. After his service in the Navy, he returned to the brick plant and met Rose Frederick in 1920. Married in 1921, they were together for more than 70 years. Rose gave birth to two children and then went to work at the Thurber Hotel as a cook. Rose, like Herbert, was the child of immigrants who moved to Thurber. Their parents and siblings worked and lived in Thurber also. Rose, second from left, and her father, siblings, and dog all posed for this image around 1918. (Courtesy of the Judy Jacobson Collection, WKGC.)

Seven

CHANGE

W.K. Gordon had been prospecting for oil for years in Thurber and other places. He had a little success, which helped bring a little extra money into the company's accounts, but nothing like the discovery of oil in Ranger. Gordon's training in geology made him aware of what to look for. He spent many hours studying the land in and around Thurber and finally convinced the company to drill. His first well, the Nannie Walker, produced millions of cubic feet of natural gas, which unfortunately had no market at the time. He then moved to the McClesky farm and went down 3,000 feet. Edgar L. Marston told Gordon to stop, as nothing that deep had been found to date. Gordon replied that he had a hunch, so Marston gave him permission to continue. On October 17, 1917, the drilling team struck oil. McClesky No. 1 was a gusher that started a mad rush. To top things off, the Nannie Walker blew in. Gordon had been right about the rich oil under the land. (Courtesy of the Studdard Collection, WKGC.)

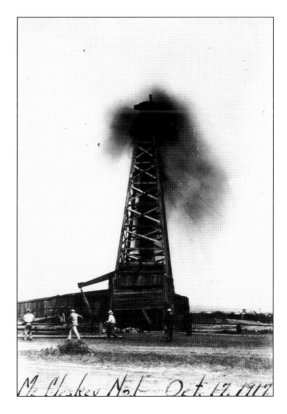

M Closker No.1 Oct. 17, 1917

With the McCleskey strike came multiple changes, including to the company's name. Within days, it became the Texas & Pacific Coal and Oil Company and issued new shares to reflect its new success. The value of the company jumped from $100 per share to $1,900 a share because W.K. Gordon had leased 300,000 acres of land deemed worthless at rock-bottom prices. Now that they had struck oil, its value soared. (Courtesy of the Miles Hart Collection, Haley Library.)

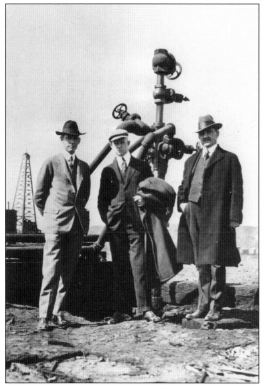

When the McCleskey well came in, W.K. Gordon was squirrel hunting with his son W.K. Gordon Jr. He supposedly took the news very calmly, although he likely felt a sense of satisfaction. The discovery not only brought the North Texas region into the oil business with a boom, but it also extended the life of the Texas & Pacific Oil Company until 1963. Gordon (far right) was instrumental in many aspects of the company from its first years, through unionization, the introduction of the brick plant, inventing new equipment, and overseeing expansion of the town, but his geological knowledge was something the company benefited from the most. He retired in the 1920s and moved to Fort Worth. (Courtesy of the Studdard Collection, WKGC.)

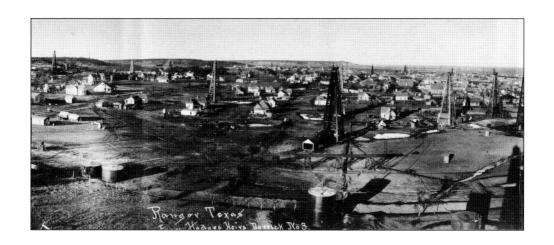

In a little over two years, 850 wells were pumping oil, and 220 were in the drilling process. With over 20 million barrels taken from the ground, the population swelled, and the town struggled to keep up with construction. The population went from 800 to 40,000 within less than two years. Just as it had in Thurber, the company began building stores and homes for its workers. A person could not look anywhere without seeing a well, no matter how sacred the ground. (Both, courtesy of the GKGC.)

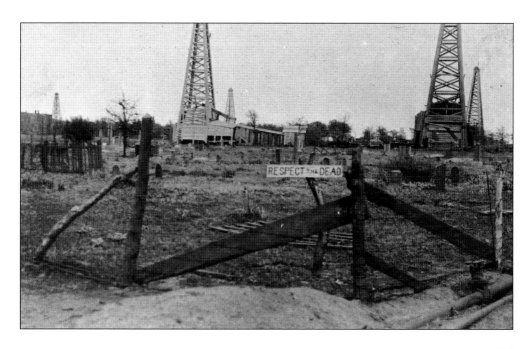

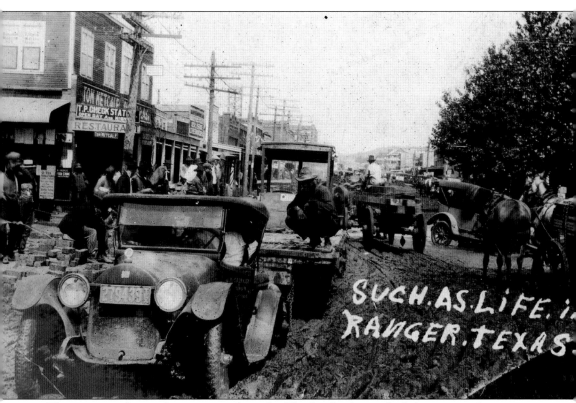

This image is alive with movement, from the Thurber bricks on the left awaiting placement to the throng of men preparing to cross the muddy bog that served as the main street. An ox hauls a wagon loaded with timbers past a man in a mud-splattered white striped shirt in a car chained to a flatbed truck in an attempt to dislodge it. On the right is another timber-laden wagon pulled by two mules approaching another car sunk in the mud. (Courtesy of the Studdard Collection, WKGC.)

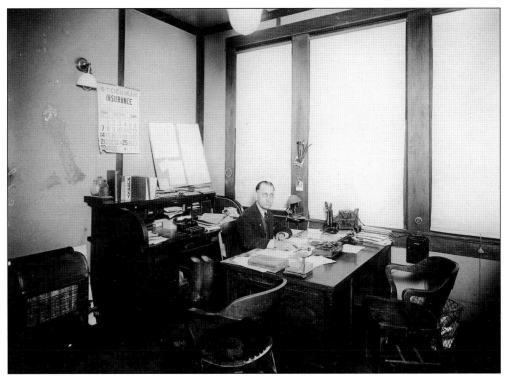

New business meant new offices and managers to fill them. George B. Studdard started work for the Texas & Pacific Coal and Oil Company in Ranger on April 8, 1920, and remained there until his retirement on September 30, 1963. He is seen here in his Ranger office. The calendar shows that it is November 1920. Personal touches include the muddied boots under the back desk and a photograph of a woman hanging near his head on the window frame. (Courtesy of the Studdard Collection, WKGC.)

Despite the enormous swath of land that Gordon secured for the Ranger area wells, the company continued to prospect, including in Coahuila, Mexico, where Pres. Porfirio Díaz invited others to help develop Mexico's petroleum industry. Pancho Villa and his forces had unsuccessfully attacked the city of Juarez in June. Venustiano Carranza, Mexico's president, was murdered six months after this telegram was sent. (Courtesy of W.K. Gordon Sr. Papers, Special Collections, the University of Texas at Arlington Libraries.)

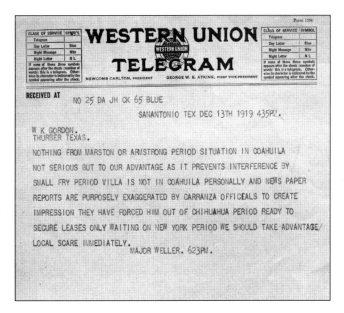

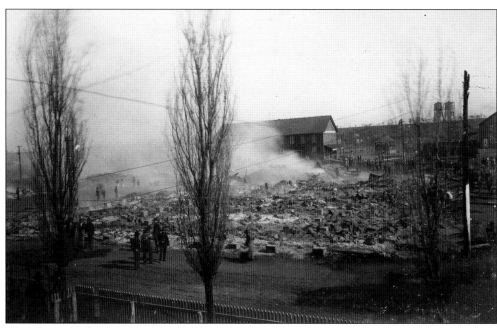

The change in focus from coal to oil kept the company moving forward into the new century. As revenue from the coal mines and the brick plant declined, profits from the demand for oil increased, with the exception of the years of the Great Depression. Thurber's population shrunk as Ranger's grew. On September 14, 1930, a fire destroyed the building that housed the meat market, hardware store, and general offices. The blame was placed on an electrical short near the freight elevator. Firefighters focused on containing the fire rather than saving the buildings since they knew the town would soon be closed down. The company chose not to rebuild, and temporarily relocated the businesses. Company offices were moved to Fort Worth in 1933. (Above, courtesy of the Lorenz Collection, WKGC; below, courtesy of the Studdard Collection, WKGC.)

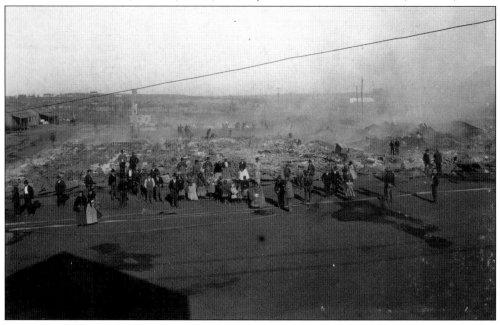

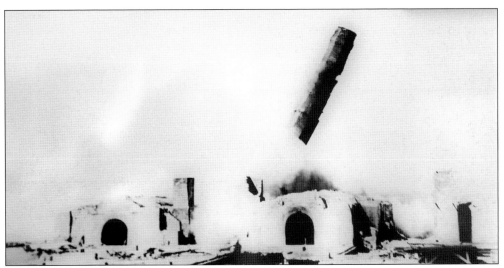

The Thurber Brick Plant closed in 1930 but did not begin liquidating equipment for another three years. After salvage companies bought all they could, workers demolished every brick structure. The brick smokestack, originally constructed in 1898 over 60 days, was toppled on March 29, 1937, with 40 sticks of dynamite. The *Fort Worth Press* reported that a crowd of thousands watched as "the base of the great chimney shot out with a dull roar, steam shovel ballooning red dust. The giant shook, tilted and crumbled . . . It came down in six seconds." (Courtesy of the Bennett Collection, WKGC.)

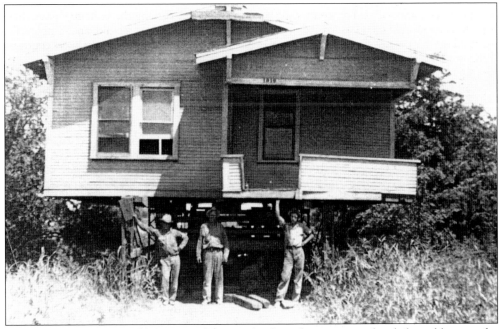

Thurber's houses were sold for around $40 each when the company decided to obliterate the town. This one, en route to its new destination, was photographed as it was crossing over Alarm Creek Bridge between Lingleville and Hoggtown nearly 30 miles from Thurber. (Courtesy of the Grady Daniels Collection, WKGC.)

Thurber's population in 2020 was five people, a far cry from the nearly 10,000 who lived there during the peak years in the 1910s. Few buildings remain to tell the story of the once bustling town, but there are two restaurants that host the many people who stop to gaze up at the smokestack that was part of the power plant. Photographs of the once thriving town line the walls of both eateries, sharing a snippet of the history that took place here. The W.K. Gordon Center is located where the north end of the Thurber Brick Company once stood and proudly tells the story of the company town. (Author's collection.)

Bibliography

Bielinski, Leo S. *The Thurber Connection*. Gordon, TX: Thurber Historical Association, 1999.

Ely, Glen Sample, and Ruby Schmidt and the Thurber Historical Association. *Boomtown to Ghost Town: Thurber, Texas 1886–1936*. DVD video. 1991.

Gentry, Mary Jane. *The Birth of a Texas Ghost Town: Thurber, 1886–1933*. College Station, TX: Texas A&M University Press, 2008.

Grimshaw, Jos David. "Hard, Heavy Lifting: The Manufacture of Bricks at Thurber, Texas." M.A. thesis, Tarleton State University, 2004.

National Register of Historic Places Inventory Nomination. US Department of the Interior. April 25, 1979.

Hardman, Weldon B. *Fire in a Hole*. Gordon, TX: Thurber Historical Association, 1975.

Herman, E.A. *Steam Shovels and Steam Shovel Work*. New York, NY: Engineering News Publishing Company, 1894.

Rhinehart, Marilyn D. *A Way of Work and a Way of Life: Coal Mining in Thurber, Texas, 1888–1926*. College Station, TX: Texas A&M University Press, 1992.

Studdard, George B. *Life of the Texas Pacific Coal & Oil Co., 1886–1963*. Fort Worth, TX, 1992.

Texas Historical Commission. *The Development of Highways in Texas: A Historic Context of the Bankhead Highway and Other Historic Named Highways*. Accessed October 3, 2020.

Tucker, Gene Rhea. *Oysters, Macaroni & Beer: Thurber, Texas and the Company Store*. Lubbock, TX: Texas Tech University Press, 2012.

Woodard, Don. *Black Diamonds! Black Gold! The Saga of Texas Pacific Coal and Oil Company*. Lubbock, TX: Texas Tech University Press, 1998.

Zintheo, C.J. *Corn-Harvesting Machinery*. Washington, DC: Government Printing Office, 1907.

DISCOVER THOUSANDS OF LOCAL HISTORY BOOKS
FEATURING MILLIONS OF VINTAGE IMAGES

Arcadia Publishing, the leading local history publisher in the United States, is committed to making history accessible and meaningful through publishing books that celebrate and preserve the heritage of America's people and places.

Find more books like this at
www.arcadiapublishing.com

Search for your hometown history, your old stomping grounds, and even your favorite sports team.